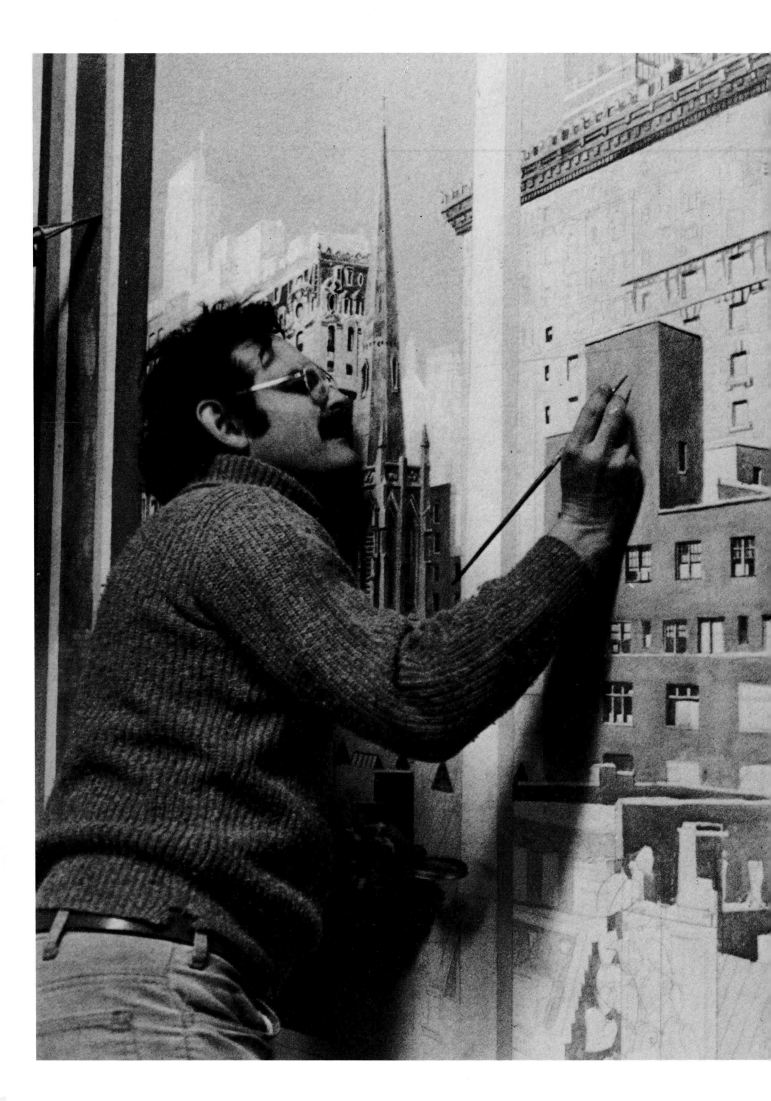

RICHARD HAAS
AN ARCHITECTURE OF ILLUSION

RIZZOLI
NEW YORK

ACKNOWLEDGMENTS

This book resulted from the collaborative effort of several individuals who worked long hours assembling many fragments and photographs and attending to innumerable details. I would like to thank all the people who work in my studio and at Rizzoli.

My particular thanks go to Brooke Alexander who assisted in making the initial arrangements with Rizzoli and whose gallery provided much of the photographic and biographical material used in the book. I would also like to thank Rhona Hoffman and the Young Hoffman Gallery for their assistance in compiling materials and meeting with the publishers. For making initial contact with the publishers I would like to thank Rosa Esman.

Paul Goldberger deserves special thanks for his thoughtful essay. Nancy Foote deserves very special thanks for her excellent editorial work and I am grateful to Nancy Rosen for helping find her. Arnold Skolnick's graphic design is also greatly appreciated. Solveig Williams was extremely helpful as editor at Rizzoli. From my own staff I would like to thank Leonard Sorcher and Jane Nisselson for their patient help in preparing the text.

I am also grateful to the clients who sponsored my work, to the art students and signpainters who assisted in many projects, and to the public and private funding agencies that helped to finance the projects.

Finally, I would like to thank my wife, Katherine Sokolnikoff, for her long patience, advice and support during the endless hours of work on projects. —R.H.

Published in the United States of America in 1981 by
Rizzoli International Publications, Inc.
712 Fifth Avenue, New York, NY 10019

LC 81-51309
ISBN 0-8478-04-7-0

Designed by Arnold Skolnick

Typography by Ultracomp, New York
Printed and bound by
Arti Grafiche Amilcare Pizzi, S.p.A., Milan, Italy

For my mother and Doris Freedman

CONTENTS

INTRODUCTION

The art of Richard Haas is at once entirely realistic and quite fantastic. It takes as its premise the making real of things that are unreal, and as such it is altogether different from the work of the new realists who attracted so much attention in the last decade. Where they took images that were absolutely real and gave them a certain unreality on the canvas, Haas does the opposite—he imagines architectural elements and then paints them in situations where they achieve a reality, almost a life, of their own.

Haas paints buildings, or parts of buildings, but his subject is much more than the architecture itself. The specifics of the architecture are secondary, powerful as Haas's love for his subjects is. For his varied oeuvre comes together to create a vision of a place, and it is the totality of that place that is as important as the message any individual piece might contain. But Haas's world, if imaginary, is not distant—its attraction comes in part because it seems so close to us, so attainable in a way that the universes envisioned by many painters are not. It seems as if it could almost have been; it is tantalizingly, poignantly, close to what is.

It is, of course, the world of architectural perfection—in which beautiful buildings stand and ugly ones fall, in which handsome architecture is hailed and ugly architecture is not permitted to exist. Haas's vision covers all periods and all styles; it is

not a little bit nostalgic, but it is far too sophisticated to be made of nostalgia alone. Haas prefers old buildings and paints them more often than new ones, but he paints with a wit and an irony that make it clear to us that he knows what he is doing. He has no illusions about our time—indeed, it is in the ironic juxtaposition of the architecture he paints and the real architecture that surrounds us that his work gains much of its strength.

Haas is now best known for his monumental trompe l'oeil urban murals, and they are, in fact, his most provocative and significant work. They function as comments on architecture and urbanism; indeed, they are among the more potent public art of our time, for they have an inherently urbanistic, and public, end. They could not have any meaning in another context, unlike much so-called "public" art which is in fact plopped down without regard to its surroundings. Most public art affects its context only by its presence, not by the specifics of its form; Haas's murals change the urban context by the ironic comments they make on that context.

But these murals—about which more shortly—cannot by themselves stand for all of Haas's art, though they surely represent the culmination, thus far, of his efforts. One should really begin with Haas's dioramas, peep-show-like boxes within which he created, in model form, visions of specific interiors, for they stand as the real entrance points to the world his art, taken as a whole, strives to

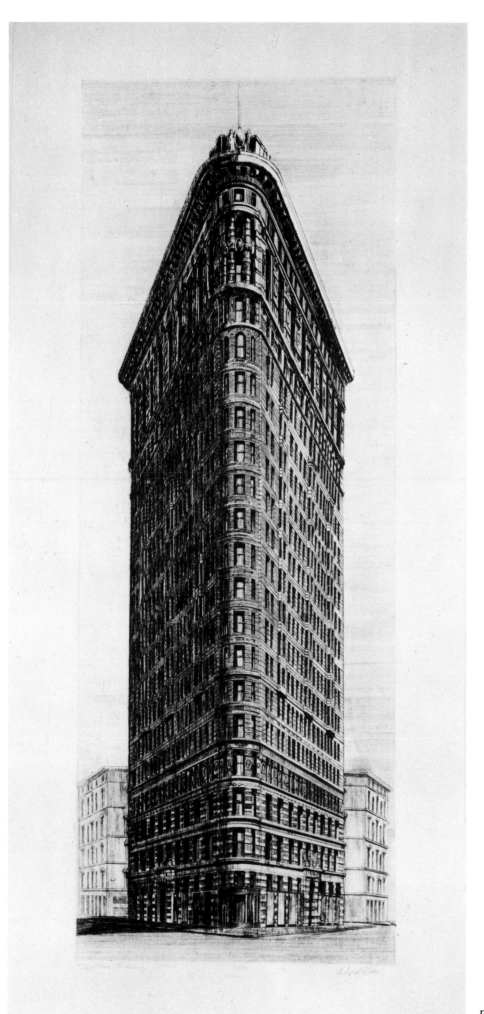

Flatiron Building, 1973,
etching and drypoint, 41½ x 17½ ″.

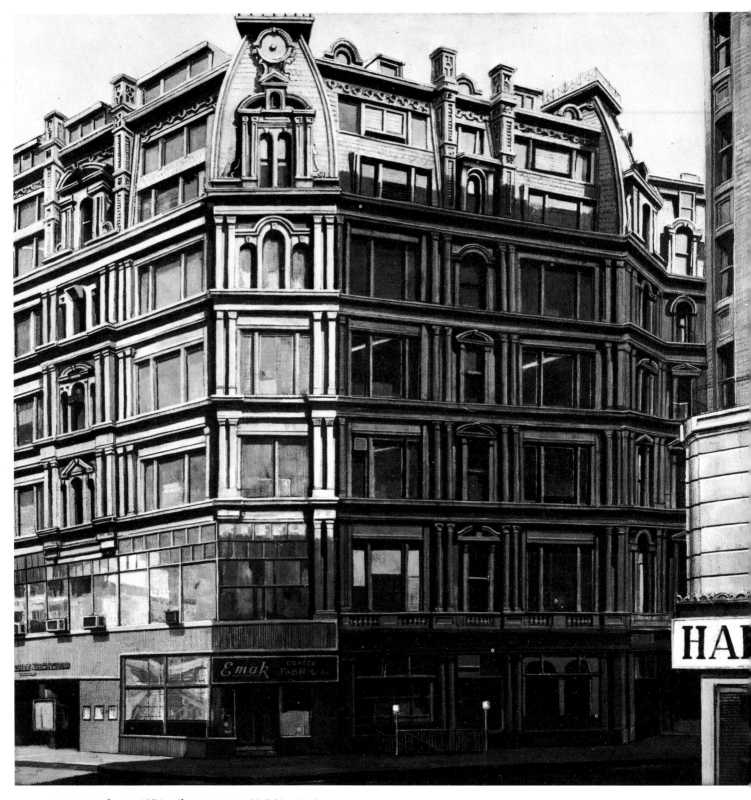

1200 Broadway, 1974, oil on canvas, 29 7/8 x 28"

Opposite page: *Greene Street*, 1973, etching and aquatint, 22¼ x 25¼"

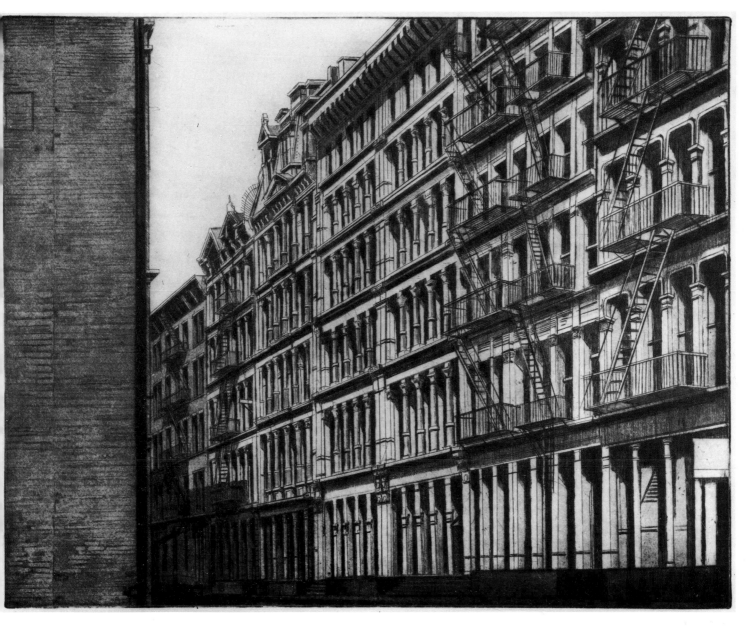

make. The dioramas have a bit of the air of Red Grooms to them, though they are gentler and have the modelmaker's benign precision. Haas constructed dioramas of Gertrude Stein in her salon, Guillaume Apollinaire in his bedroom, Frank Lloyd Wright and Giacometti in their studios; he also made boxes in the style of interiors by Vermeer and Van Eyck.

Every one of these constructions has a certain charm to it, but charm alone, of course, is not art. Haas's dioramas came after a period of considerable stylistic meandering in painting, including a flirtation with Abstract Expressionism (about which he says, significantly, "I never really felt the paintings"); like many artists, he was recapitulating the history of his medium for himself. The dioramas seem, if anything, to have been an attempt to break out of that pattern, not only to move, for the moment, away from painting, but to move away from the compulsion to make art at all in the conventional sense. The dioramas are pictures of art,

playful comments about art more than major works themselves; and they seem, literally as well as figuratively, to be a way for an outsider to look into the world of art. It is as if Haas tired of trying to follow those artists, and sought to pay homage to them instead—by making three-dimensional pictures of them.

The dioramas have great finesse, but it is their gentleness, in the end, that is their most pleasing quality. They are neither too precise and hard nor too sentimental and soft, but exist at a welcome point in between. This particular balance is equally evident in the next phase of Haas's work, the drawings and prints which he made from 1969 on of buildings and architectural details.

Haas moved to New York from the Midwest in 1968, and he has recalled that the city both overwhelmed and inspired him. He had been moving cautiously away from abstract painting in his dioramas, but now he shifted more decisively toward a kind of realist art based on the physical

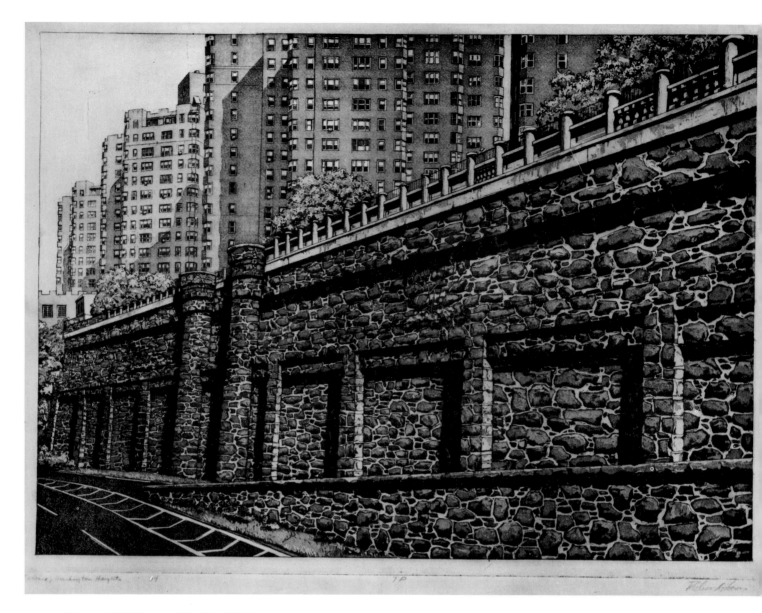

Terrace, Washington Heights, 1975,
etching and aquatint, 22¼ x 27¼ ".

city. Haas had been interested in architecture since
his childhood days in Spring Green, Wisconsin, in
the shadow of Frank Lloyd Wright's Taliesin.
Wright was almost a mystical presence to Haas, not
a mentor, and this interest took a long time to
translate itself into the artist's work. But once in
New York it rose to the fore—first through the final
dioramas, which were not looks into the private
interiors of artists' lives but models of sections of
the SoHo neighborhood. As before it was a way of
making a perfect, private world, but this time the
source material was architecture.

Almost immediately Haas began his printmak-
ing, first with a series of views of cast-iron facades
in SoHo, later with a variety of late nineteenth- and
early twentieth-century eclectic buildings in Man-
hattan and, eventually, similar buildings around
the country. The works in this series are all roughly
similar in style. There is a lovely balance in them
between softness and strength; Haas portrays these
buildings as benign, gracious presences, full of tex-
ture and detail but never so powerful as to be

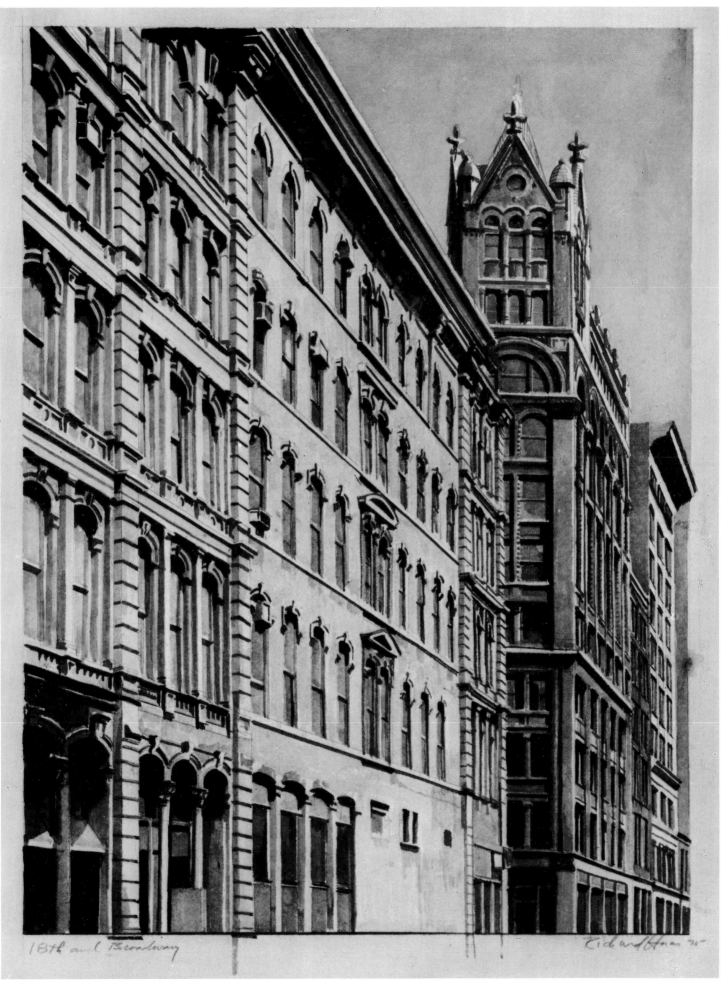

Eighteenth Street and Broadway, 1974, pencil and watercolor, 20 5/8 x 15¼".

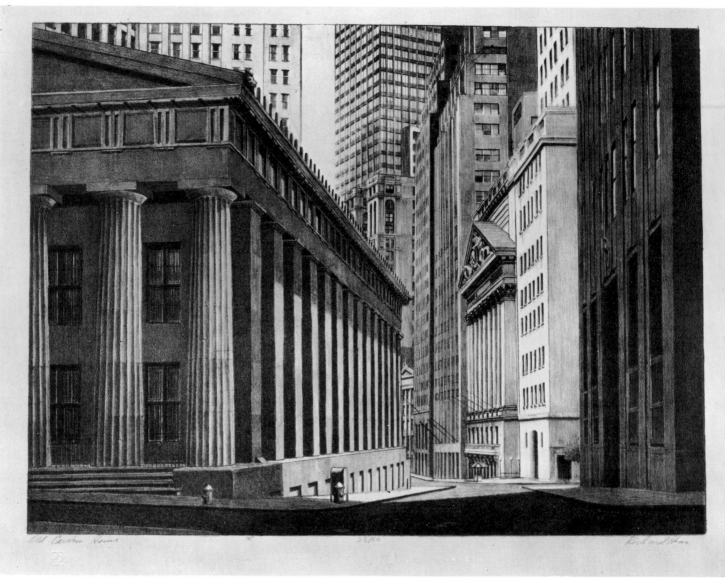

Old Custom House, 1975, color lithograph, 20 7/8 x 26¼ ".

intimidating. There is none of the precision of a Beaux-Arts presentation drawing to Haas's prints, but neither is there the casualness of, say, a David Macaulay sketch. One senses that Haas has struggled to portray his subjects faithfully, with no blemishes hidden, yet in such a way as to make them seem appealing. Significantly, the buildings in the drawings and prints of these years stand alone, floating on neutral backgrounds or surrounded by only the merest suggestion of other architecture.

A number of prints from this period stand out as exceptional. *The Flatiron Building*, done in 1973, has a slightly distorted perspective which makes the tower seem to be sailing right into us; in its composition, though surely not in its style, it recalls the great Cassandre poster of the prow of the Normandie. Haas's ability to make us feel the extraordinary shape of the Flatiron Building comes at no cost to our appreciation of the details; the rich texture of the building's surface is very much there, though it is secondary. The priorities were reversed in an earlier print, *The Bayard-Condict Building* of 1970, for here Haas realized that the facade and cornice details of this Louis Sullivan structure were all, and instead of trying to portray the entire building, he zoomed in on only a section of the facade. The details are reproduced softly, but accurately; once again the style is crucial—there is neither the harshness of photo-realism nor the sentimentality of academic art. Yet the images are too stylized to be called deadpan—despite their frontality they do not present an indifferent posture.

By the mid-1970s Haas's painting, drawing and printmaking had begun to shift away from portraits of single buildings toward an attempt to capture a wider swath of the cityscape. He began by inching into something broader, as in *1200 Broadway*, of 1974, which portays the Gilsey Hotel, a grand cast-iron structure in mid-Manhattan. Haas gives the building the same strong, yet benign, air he confers on most of his subjects, but here there is a sliver of an ordinary building across the street framing the right edge of the painting. It at once enlivens the composition and creates a vibrant foil for the Gilsey, which suddenly becomes a structure on a real city street: it is no longer isolated, appearing to float in its own space, as are most of the earlier images.

From there it was only a step to broader views still—to an entire block of Greene Street in SoHo (in an etching entitled *Greene Street*, of 1973); a lithograph of 1975 of the view down Nassau Street to Wall Street; a 1975 etching of apartment buildings atop a great battlement in Washington Heights; or a 1974 watercolor of the streetscape of Broadway south of Eighteenth Street. In each of these works—which stand, of course, for many others—Haas is looking at the city as a complex entity, as a landscape comprising a variety of textures and eras; he is telling us not only about buildings as individual works of architecture, but about how each building relates to its neighbors and about how together they form a whole that is more complex than any of its parts. We feel these places as streets—as assemblages of buildings in a public way along an open space. Haas clearly has a very noble view of the urban street—to him it is obviously of high public purpose, and its buildings, by virtue of their common presence on it, bear a considerable responsibility. One thinks that he must have known that wonderful remark of Louis Kahn: "A street is a room by agreement."

These works are compositions—we feel in *Greene Street*, for example, the rhythms of the cast-iron fronts that together form the major part of the image playing off against the solid masonry wall that balances them across the street. Here Haas's ability to create a composition from the existing streetscape is not unlike the esthetic decision a photographer makes; in each case the placement of objects within a carefully selected frame is a crucial part of the work.

The etching entitled *Terrace, Washington Heights* is a more intriguing effort at composition-making. Here, we are not quite sure whether the real subject is the great stone wall or the apartment towers above; first it seems to be one, then the other, and the result is a tension between the two that reveals the true struggle they engage in on the cityscape. In *Old Custom House*, on the other hand, the Nassau and Wall Street lithograph, the theme is the serene, almost innocent relationship between the old Custom House (now Federal Hall) which anchors the left side of the composition and the pasted-on facade of the Stock Exchange building down the street. We feel the massive solidity of the old Custom House, which is deftly cut off by the left edge of the picture, and the weakness of its echo in the thin, classicizing stage set of the Stock Exchange. And beyond the interplay between these two buildings we feel the sense of old Wall Street itself—heavy self-assurance expressed in stone.

It was perhaps not surprising that Haas, after doing so well with his views of blocks and streets, would step back yet again and attempt to take in whole cities. This he did in late 1979 and 1980 in a series of city views, watercolors that struck a broad panorama across, among other places, San Francisco, Manhattan and Albany. But these are probably his least successful works—they are almost too pleasant, too easygoing and nostalgic; they lack the directness and the potent juxtapositions present

in the closer-in city views. The San Francisco panoramas are technically strong, but artistically somewhat flat and dull—one senses that a photograph could have brought as good or better an effort, something which could never be said of Haas's other works. This is so with the Manhattan panoramas as well—as the net has been cast so wide, it seems to have lost a crucial depth.

In any event, Haas's attentions by the middle of the 1970s were clearly focused on large scale, and on the issue of the cityscape as a whole. These concerns found their best expression not in painting and printmaking, but in the public art that has by now become Haas's trademark. His large-scale muralmaking actually began when, under the enthusiastic sponsorship of the art organization City Walls, he produced a trompe l'oeil version of a cast-iron facade to cover the exposed, blank side wall of a cast-iron building at the corner of Prince and Greene streets in SoHo. The mural is, in one sense, a continuation of Haas's earlier work in that it is a gently drawn, affectionate rendition of architectural details. But it also represents a distinctive departure, for it brings the work both to public scale and to a major public function. The idea here is not merely to show us a tiny glimpse of a much-beloved architecture, as in the dioramas and prints and watercolors, but to alter the real city.

The mural really does transform a corner of New York. It pays homage to the real cast-iron facade, and by implication to all the cast-iron fronts of SoHo, but it is also about completion—about the filling in of a missing part, the making of a totality. Haas is attempting to make the neighborhood whole. But he does so with a certain hint of irony— we know that the wall is not real, and we realize that it is all something of a game that the artist is playing with us. But Haas takes the ideas behind the game very seriously—it is hard not to think that he really wants to make over the city here. He is not after primness or excessive order, but a certain kind of wholeness.

Haas's smaller murals on Mulberry Street in New York's Little Italy, between Hester and Grand streets, and on the Strand in Galveston, Texas, have a similar goal. In Little Italy he has painted the side of an old warehouse to resemble a group of storefronts, and architectural details are carried from the old building into the mural. In Galveston he carried the Italianate details of a row of buildings across the facade of their drab neighbor. So one senses once again the desire to make the city more complete— to finish the street in Galveston, to finish the building in Little Italy and bring to it the street life that Mulberry Street has elsewhere. It is the making of an image of the world that is almost as it is, but just

18

Nob Hill, View East, 1979, watercolor, 18¼ x 34".

a little bit better—the themes of Haas's dioramas carried out into the street.

Haas's public-scale work has moved gradually toward greater and greater illusion. The SoHo, Little Italy and Galveston murals were essentially extensions of existing architecture onto blank walls; not long after their completion Haas began another series in which he projected not existing facades but the shadows of demolished buildings onto blank walls. Probably the best of these was a plan, never executed, to paint an imagined shadow of the original Madison Square Garden on the blank side of a huge old loft building just north of Madison Square; had it happened it would have been at once an elegant abstraction and a cogent piece of architectural criticism. Not quite so subtle was a scheme to paint the shadows of the Empire State Building and the Chrysler Building on the towers of the World Trade Center—an idea a bit too self-conscious, perhaps, and in any event rather insistent in its reminder of a comparison that is all too obvious.

But the shadow projects, though not executed, began Haas's move toward less literal work. That move saw its first major executed result in Boston in 1977, with the completion of a vast mural, first conceived in 1975, for the blank rear facade of the Boston Architectural Center, a harsh, cold structure of raw concrete that is the archetypal piece of 1960s

brutalism. What Haas did here was to ignore the existing architecture and produce a cutaway view of an imaginary classical structure, with balustrades, columns, arches and a great central dome. It looks as if a huge knife had sliced into this concrete box, revealing an extravagant classical design in section.

The Boston mural makes an obvious, though welcome, comment on the architecture of the building; but it is in the design of the mural itself that this work becomes truly special. The mural plays off not only against the building, but against the city of Boston—it changes mood and tone depending upon the angle from which it is seen. Along Newbury Street, behind the Boston Architectural Center, it is a pleasing, curious presence as it sticks up above the low, red brick houses that line the street. From a few steps farther back, the towers of contemporary Boston, the Prudential Center and the John Hancock tower become visible above the building, and they heighten the irony of the classicizing fantasy and give it a more serious, hard-edged tone. But the mural looks best of all from Boylston Street, where the Institute of Contemporary Art blocks the concrete sides of the Boston Architectural Center, so that only the Haas mural is visible, and there is a wonderful instant of illusion in which one wonders if this is not a real classical vision. The moment passes, but the monumentality

of the statement remains.

Haas tried to make similar gestures in another mural, completed in 1978, on the blank side of a red brick Consolidated Edison power station on Peck Slip in lower Manhattan. Here an imaginary, but fairly conventional, four-story Federal building is painted next door to an altogether unusual limestone structure conceived wholly in Haas's imagination; it has an open arcade cut through its middle, framed by Ionic columns and pilasters. Through the make-believe arcade is painted the image of the Brooklyn Bridge, the real tower of which looms up over the mural just to the north. So the view through the arcade is essentially what one would see if the Con Edison building did not exist, though with perspective altered; here Haas is merging the classical imagination he displayed at Boston with the desire in his earlier murals to render the city whole according to his own order.

The monumental grandeur of the Boston mural is not equaled at Peck Slip, however: perhaps it is the smaller scale, perhaps the somewhat more obvious game-playing involved in the illusionistic classical arcade. In any event the work comes off more as pleasing entertainment than as profound urban transformation. On the other hand, Haas's only international project to be realized thus far, a

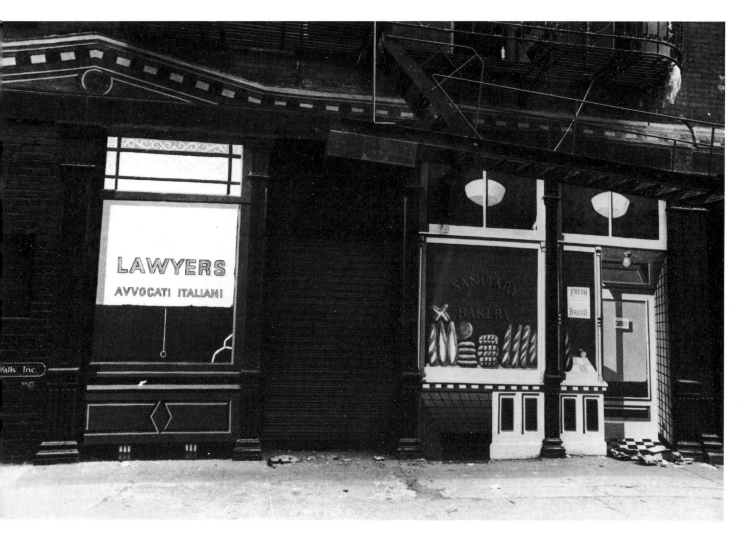

Mulberry Street Facade, 1976, Little Italy, New York, 12 x 30'. Commissioned by City Walls, Inc., executed by Van Wagner Outdoor Advertising. Opposite page: the original wall; left: detail of the lawyers' office.

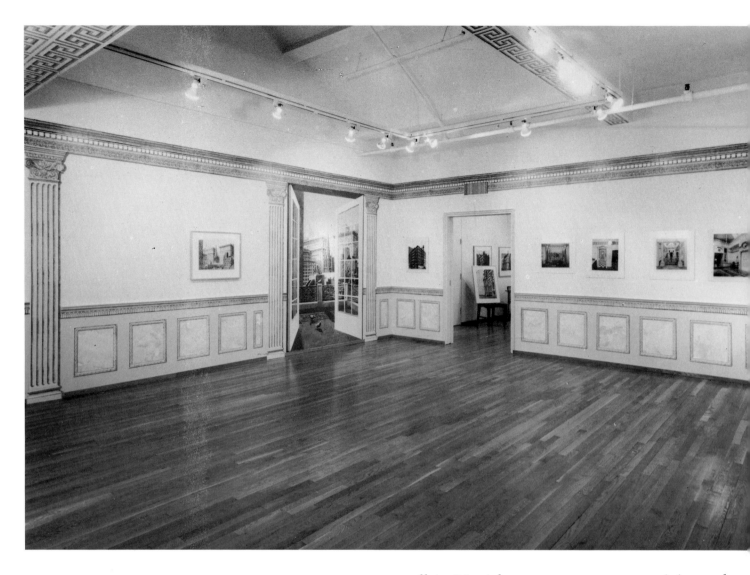

Above: installation view, east and south walls,
Brooke Alexander Gallery, New York, March-April 1977.

wall in Munich, seems at once entertaining and quite striking. An imaginary nineteenth-century townhouse facade is painted on a blank wall made conspicuous by the destruction in World War II of its neighbor; Haas has given this facade great grace and rhythm, with a well-proportioned central bay and a two-story entrance opening into a sixteenth-century courtyard. Here the balance between reality and fantasy is an almost perfect one—this is not a continuation of an existing facade, as at SoHo, or a complete invention, as at Boston, but something with elements of both. And as a sort of coda to the main work, Haas turned a smaller structure next door into a neoclassical carriage house, painted with its door slightly ajar and a 1932 Mercedes Benz reposing within.

Two unrealized Chicago projects attempted similar period-style juxtapositions. *Chicago Arcade* is a scheme in which Haas sought to paint the blank side of an old six-story industrial building with an immense domed arcade; one would have thought that this ordinary brick front was suddenly giving way to monumental classical grandeur. It would have been more realistic in its tone than the Boston mural, though no less spectacular; one senses that

Opposite page: *View of Fifty-seventh and Fifth,*
1977, oil and acrylic on canvas and wood, 96 x 72".

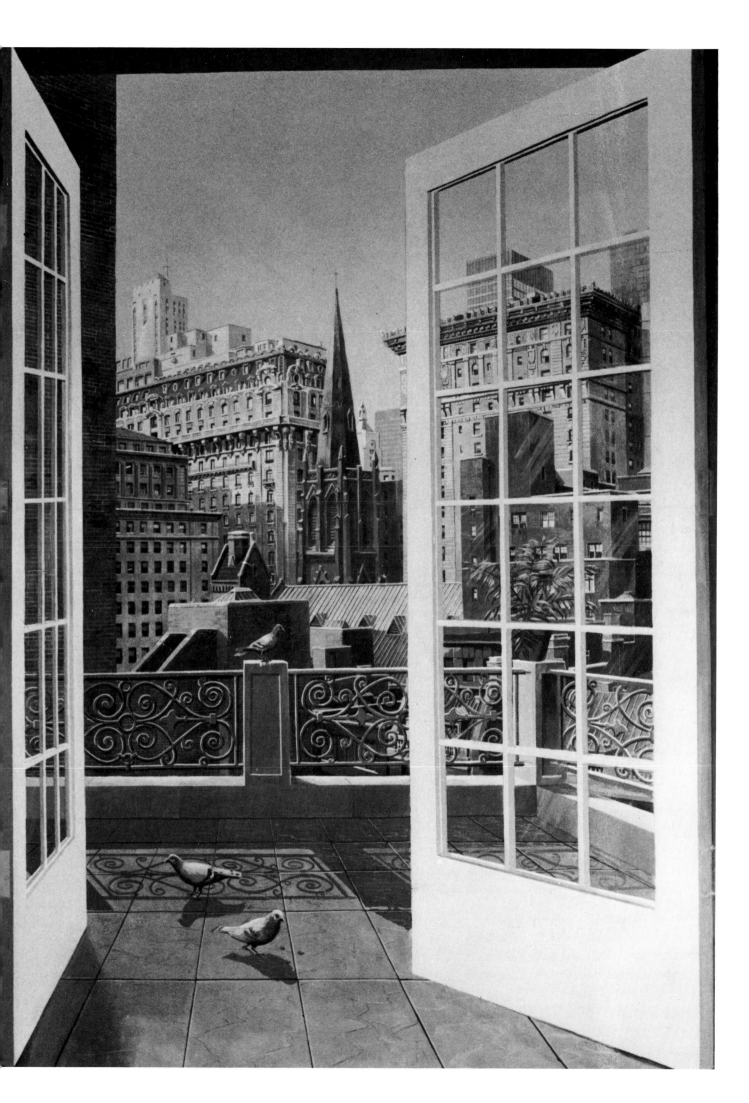

this scheme would have been both startling and powerful. For 700-720 North Michigan Avenue, a narrow, blank-sided tower that is likely to be demolished, Haas proposed another spatial illusion —a trompe-l'oeil arch cut out through the middle of the side, so that it would appear as if the entire building were shaped, in profile, like a tall arch.

But while these projects were not executed, a far more ambitious Chicago scheme has been realized —the painting of three facades of a twenty-story apartment house on LaSalle Street. Haas here had 80,000 square feet of surface to cover, and could create a three-dimensional object—he could, in effect, design a whole building and see it painted on an existing structure. The work that emerged from this unusual challenge is, significantly, not a conventional-looking building at all. Entitled *Homage to the Chicago School*, it is an amalgam of elements taken from celebrated buildings by Chicago architects, most prominently those of Louis Sullivan. An entrance arch is modeled after Sullivan's arch at the Transportation Building at the 1893 World's Fair (though with painted bas-reliefs of Sullivan, Frank Lloyd Wright, John Wellborn Root and Daniel Burnham), and the top of that facade contains the great arched window from Sullivan's bank in Grinnell, Iowa. Connecting the two is an eight-story central shaft of "Chicago windows" in which a reflection of Holabird and Root's Board of Trade building has been painted.

This tower, completed in 1980, followed a version of the Times Tower Haas painted on a bland industrial building just south of Times Square in New York in 1979. The Times Tower and the Chicago project are his only three-dimensional buildings; as such, they inspire greater expectations than the two-dimensional murals—the act of illusion this time is more complete. It can also be more coy, for the obvious make-believe that so empowers such successful Haas works as the original SoHo mural or the Boston Architectural Center mural is not present. One almost can think that these are real, at least from a distance. But Haas does not exploit this illusion; he seems ever conscious of the value of the ambiguity between reality and illusion, and both of these buildings are painted with frequent reminders of their make-believe quality. At Chicago it is the very amalgam of the design itself —a decent composition yes, but so bizarre a marriage of architectural elements that we sense quickly that it is a fantasy. At New York the references to a single, and once-real, work of architecture are more direct, but Haas has painted only a tower; it sits on a base that reminds us instantly that we are really in the Times Tower-less New York of today. But in both cases these works, like Haas's earlier

murals, are acts toward completing the city, conceptually if not literally.

The power of the existing city—the "real" city —both energizes and compromises these urban works. It is from the juxtaposition of Haas's world with the existing one that his works gain much of their artistic tension, as I have said, even though there is a sense of constant struggle, a sense that the existing city wears down at these works like water cutting its way through rock. The murals will always be the more delicate part of the cityscape. Haas seems to recognize this, for in the last few years, at the same time that he has moved toward large-scale, fantastic architectural murals, he has also created a substantial number of interior designs. Here he can control the entire environment; in 1977 he turned the Brooke Alexander Gallery into a neoclassical room complete with two-dimensional Corinthian pilasters, wainscoting and trompe l'oeil French doors giving out onto a Manhattan vista. At the Young Hoffman Gallery in Chicago Haas erected a similar project, this time with Chicago School details covering the walls.

Putting aside the interior design implications of this sort of instant classicism or instant Sullivanism—which are substantial, surely a more pleasing response to the absence of fine craftsmanship in our time than any architect has come up with—the illusionistic interiors offer us not inconsiderable insight into Haas's art. There have been other interior works, mostly classicizing and mostly done for private clients, but probably the finest is the thirty-foot-long room Haas created in 1981 for a temporary exhibition at the Massachusetts Institute of Technology. Here, painting on foam core, he made a full classical room, with Ionic columns and pilasters and a shallow dome, but the room was not executed in uniform fashion throughout. At the entrance end it began as a sketch, and it evolved gradually into a full illusion. Haas has referred to it as "a means of dealing with the transition from contemporary space to that of illusion to avoid making a jump, to use illusion as a means of inviting us in."

Here Haas is dealing, clearly, with full-fledged architectural problems. He has also manipulated the space slightly, creating an illusion of tapering, as a further gesture. It is undoubtedly somewhat didactic, but in its ability to keep illusion at arm's length—to use it and yet not to be overtaken or controlled by it—this work is significant. It reminds us again that Haas's imaginary world is not one of pure make-believe, cut off altogether from what we know, but indeed one close to that which we have around us.

Haas's art does, undoubtedly, come back in its maturity to where it began—not in the halfhearted

Opposite page: installation views, Young Hoffman Gallery, Chicago, 1978.

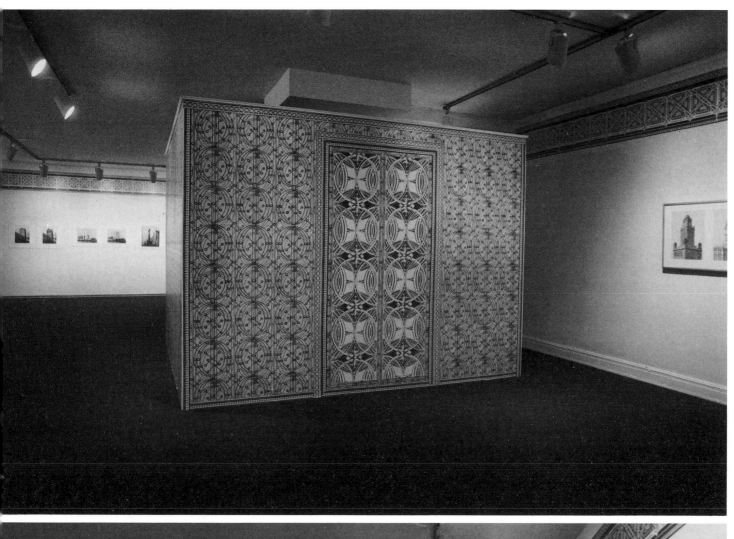

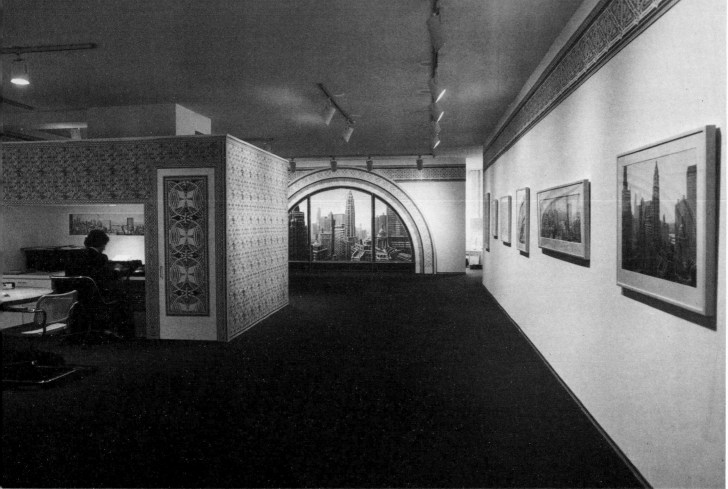

Dakota Entrance, 1974, lithograph, 19¼ x 22½".

attempts at abstract painting, but in the making of the dioramas that were his true early passion. Now, as then, he is concerned with a kind of ideal world, with the righting of what he sees around him that looks wrong. His is not the revolutionary stance; what intrigues him more than destroying his environment is finding that slight change that will make it right.

That is what ties the addition of a painted cast-iron wall in SoHo to an imagined classical interior in Boston or a fantasy version of a Chicago skyscraper—each is based on a love for something existing and on a desire to make it into something more. Haas's art is an ode to things that have been made, an illusion about things that are real.

Paul Goldberger
New York, June 1981

26

EARLY INFLUENCES AND EARLY WORK

In order to reconstruct the past influences that led me to how I think and see today, I have to blank out large portions of the obvious chaos of my life and focus on those moments, events and memories that seem to give some semblance of order and logic to my present. We admire the myth of direct progression and connection even though we know it never happens that way.

I was born in Spring Green, Wisconsin, in 1936, of an immigrant German father and third-generation German mother. Spring Green was a very small midwestern town with two intersecting main streets, a small marble-columned bank, a corner drugstore with an Art Deco soda fountain, a cinema where Tom Mix and Roy Rogers played on weekends, three churches, my father's butcher shop, and a four-room wooden grade school with the public library in the basement where I discovered *National Geographic*. Most importantly, about one mile south of town across the old Wisconsin River Bridge was Taliesin, the home of Frank Lloyd Wright.

Though he was seldom seen, his presence permeated the town, giving it a certain mystery and a sense of belonging to a larger world than that contained by the bluffs and sandstone ledges on either side of the Wisconsin River. I remember one Saturday night when Mr. Wright and his entourage came to the cinema. He in his flat hat, cane and cape step-ped out of a rust-colored Lincoln Continental with an oval rear window; the other members of the Taliesin Fellowship parked miniature Austins of the same color nearby.

I toured Taliesin when I was about eight with my father, cousin Herman and Uncle George, who was then just starting as Taliesin's stonemason. We saw room after room with exotic Buddhas, Japanese screens, harps and grand pianos, a courtyard containing peacocks, an ornate old carriage, sleighs and Japanese bells hanging from trees. There was truly a world of mystery across the river, one that would draw me back some ten years later when I could more thoroughly appreciate the place.

We traveled a lot by car as kids as my father could never sit still (wanderlust is a trait I've inherited from him), and the car was then an easy and cheap way to pack off six people—my parents, two brothers and sister and me. Among our many trips was one to Spillville, Iowa, where two Czech brothers had carved several wooden blocks with moving parts in the shapes of churches and castles. I also remember a large dollhouse at the Museum of Science and Industry in Chicago and the many dioramas, miniature and life-size, in the Milwaukee Museum. Facsimilies of architecture always intrigued me. I was constantly poring through the *World Book* encyclopedia and world atlas (which was mostly what our home library consisted of) and

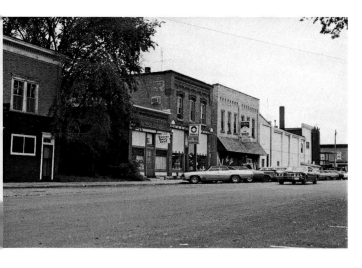

Main Street, Spring Green, Wisconsin.

Frank Lloyd Wright, Taliesin North, 1911.

Untitled, 1964, oil and collage on canvas, 48 x 47 ".

committing the pictures to memory. Maps, plans and aerial views were particularly fascinating; I remember cross-sections of luxury liners, department stores and hotels in the *World Book* that showed each level including the underground workings in section, and I would reconstruct these in modeling clay. I also made endless maps of imaginary cities, states and countries, sometimes drawing aerial views of the cities showing every building and the patterns of how the city grew in stages.

We had picture albums from my parents' wedding trip showing postcards and photos of Bavarian palaces such as Neuschwanstein, Linderhof and Nymphenburg, as well as many views of Rome and the Vatican. My mother or father would fill in with descriptions of what couldn't be seen in the photographs; I did a painting of Neuschwanstein when I was nine based on one of those postcards.

My intrigue with Taliesin and Frank Lloyd Wright continued to grow, and in high school I read all the books by or on him that I could find. I also began to make drawings of buildings based on his style; houses, churches, motels with flat roofs and horizontal window bands. Though we no longer lived in Spring Green (we had moved when I was eight years old to Milwaukee) I persuaded my Uncle George to let me work for him in the sum-

mer of 1955, when I was nineteen; this he arranged with Mr. Wright's approval. I could then study the entire workings of the fellowship firsthand, see the drafting rooms and the work going on there, the gardens, the food, the construction, which was constant and very slow, as well as talk to some of the members of the fellowship. I spent most of my time looking at many drawings and facsimiles of drawings stored in the ante-room of the drafting area. (I was not there in any formal or rigid work capacity, so I simply hung around and absorbed the place.) I also started doing watercolors in earnest while staying there. Recently I found two from this stay and they had a Cézannesque touch. Since a Skira book of Cézanne's oils and watercolors was my first art book purchase, this doesn't surprise me.

My interest in painting was growing rapidly at this time and soon eclipsed my desire to become an architect. This was reinforced by seeing the many detailed working drawings necessary for an architectural project and my general boredom with architectural drafting. I also had received much encouragement in painting classes from my painting instructor, Joe Friebert, at the University of Wisconsin, Milwaukee, where I was a full-time first-year student in the ''unclassified'' division. His encouragement went well beyond the classroom to discussions at the Chicago Art Institute or

Untitled, 1964, oil and collage on canvas, 72 x 60 ". *Untitled*, 1964, oil and collage on canvas, 60 x 52 ".

at his home about the entire history of art. I particularly remember his enthusiasm over Rembrandt, Sargent and Eakins. Another encouraging instructor was Robert Von Neuman, who taught printmaking and who had learned lithography in Berlin in the early 1900s.

These regular trips to the Chicago Art Institute with my instructors and fellow art students introduced me to both contemporary and historic art. In my four years at the university, I saw exhibitions of Seurat, Picasso, Gauguin, Toulouse-Lautrec, Mondrian and interesting contemporary American works in the institute's annual exhibition by such artists as de Kooning, Pollock, Rothko, Kline, Hofmann, Still and many others. I increased the size of my brushes and paint tubes and began to paint as closely as I could to Kline and de Kooning. At about this time Jack Tworkov came to teach a summer class at the university and I enrolled to get closer to this new heroic style I was discovering. I found the look of Abstract Expressionism but never really "felt" it, and my paintings seem funny to me as I look back at them today.

The next six or seven years were filled with style jumping. The California figure painters Diebenkorn and Bischoff, or the early hard-edge and color-field works by Held, Louis and Noland as well as Rauschenberg collages were to be the chief influ-

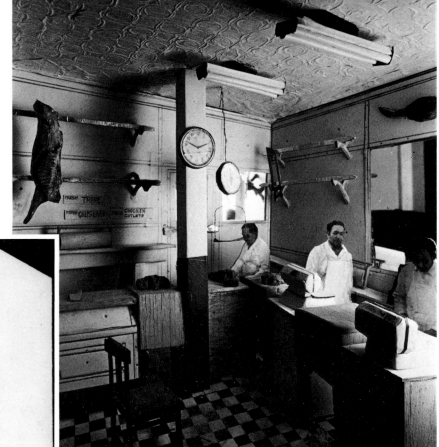

Porcelli's Meat Market, 1969,
mixed media diorama, 15 x 12 x 18″;
inset: exterior of diorama.

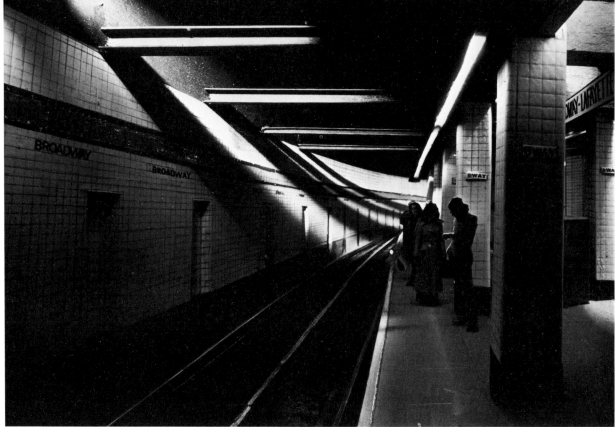

IND Subway Station (Lower Level),
1969, mixed media diorama, 18 x 27¾ x 22″.

Greene Street Looking South,
1969, mixed media diorama, 16 x 16 x 19″.

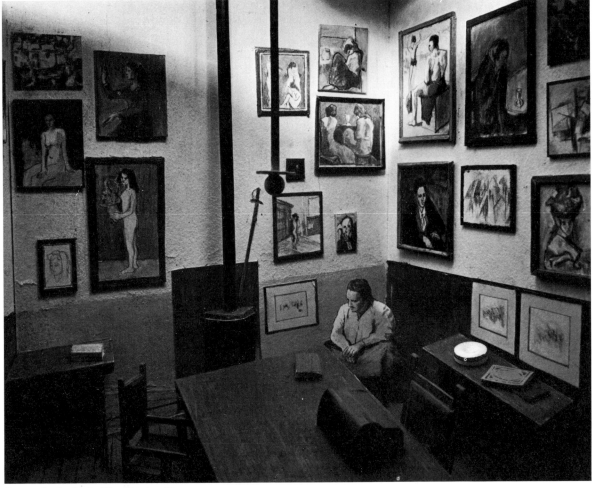

Gertrude Stein in Her Dining Room,
1968-69, mixed media diorama, 15 x 15 x 18″.

33

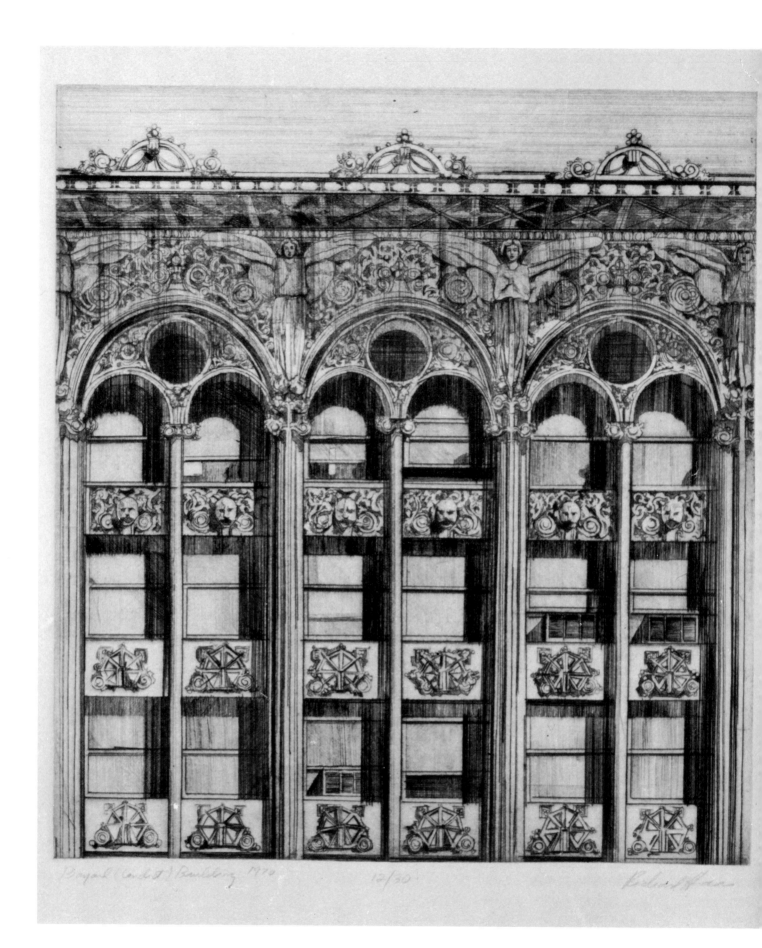

Bayard-Condict Building, 1970, etching, 20 x 16".

Haugwought Building (detail), 1969, etching, 15 x 20".

Donald Judd's Loft, 1970, etching, 22½ x 25".

Cary Building (detail showing self-portrait in window), 1970, etching, 22¼ x 25½".

ences inflicted on my painting as I tried to assimilate and imitate those avant-garde works seen mostly in museums and magazines. I received an assistantship to study at the University of Minnesota in 1961 and my contact with two artists there, Peter Busa and Malcolm Myers, was particularly important. Peter had just arrived from the East and was working in a manner related somewhat to Hofmann, laying chunks of color next to large open fields. In my paintings I began using large billboard papers in blues, reds and yellows with bold papered letters that were torn and pasted into them. In 1962, Peter wanted someone to go with him to Provincetown to help work on his house that needed an addition and some repair and I went along for two months of crazy, disconnected events, partly keeping Peter on track, but also seeing or meeting the many artists who still summered at the cape. Peter's house was on Commercial Street, a few doors down from Robert Motherwell and Helen Frankenthaler's, and I would observe them and their guests, among them Kenneth Noland and David Smith. Hans Hofmann, Mark Rothko, Jack Tworkov, Paul Burlin, Chaim Gross and Red Grooms were among the many artists I remember seeing that summer. For the first time I felt I needed to get to New York, or at least to the East, closer to the artists and the dynamics of the art scene. But it

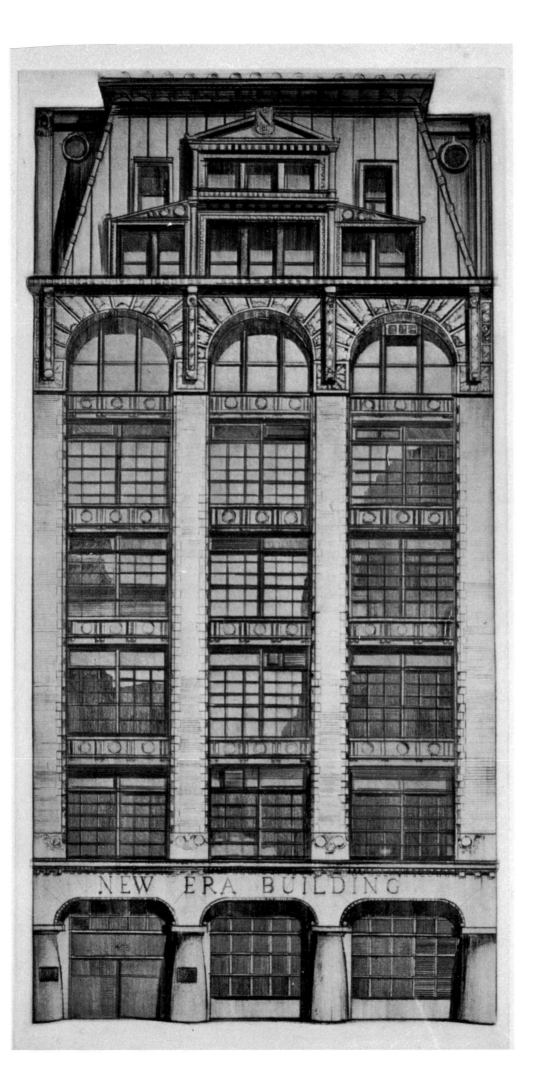

New Era Building,
1971, etching, 34¼ x 20″.

Galveston, 1972, etching and aquatint, 20¾ x 26″.

Galveston, 1972, etching and aquatint, 26 x 20 ¾ ″.

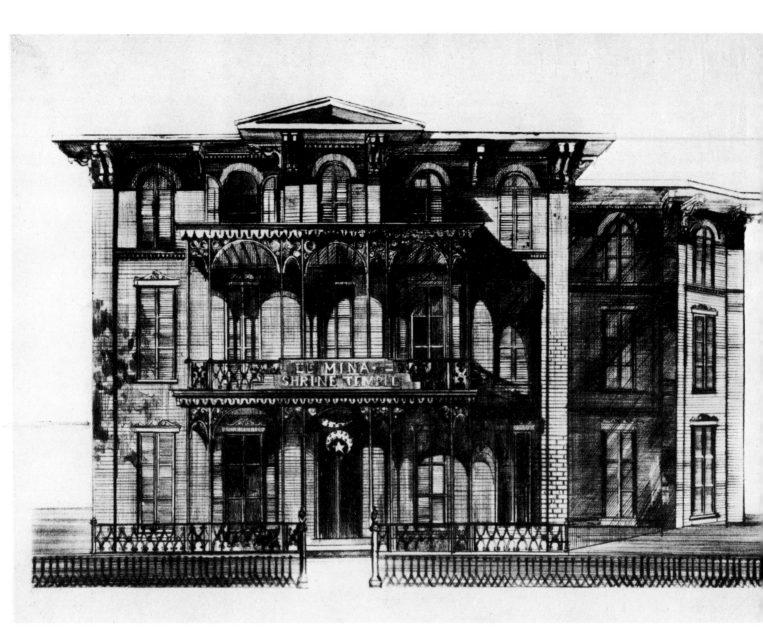

Galveston, 1972, etching and aquatint, 20¾ x 26″.

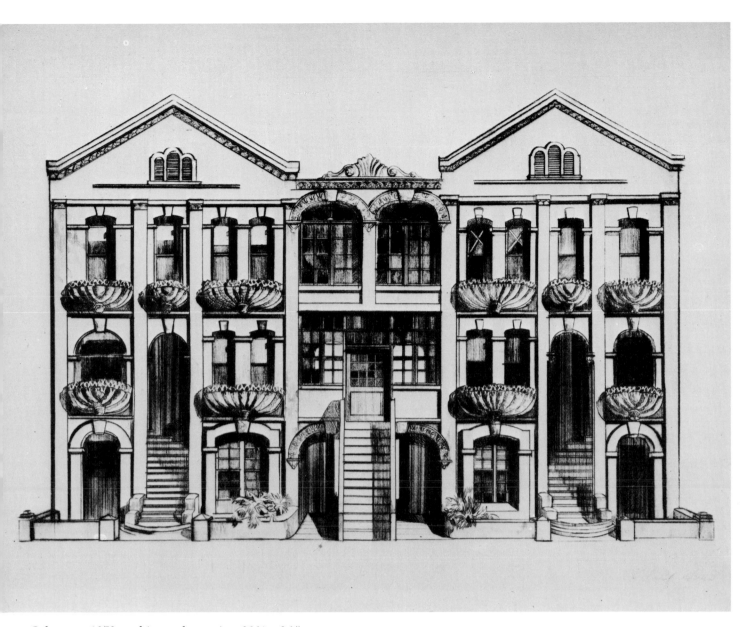

Galveston, 1972, etching and aquatint, 20¾ x 26".

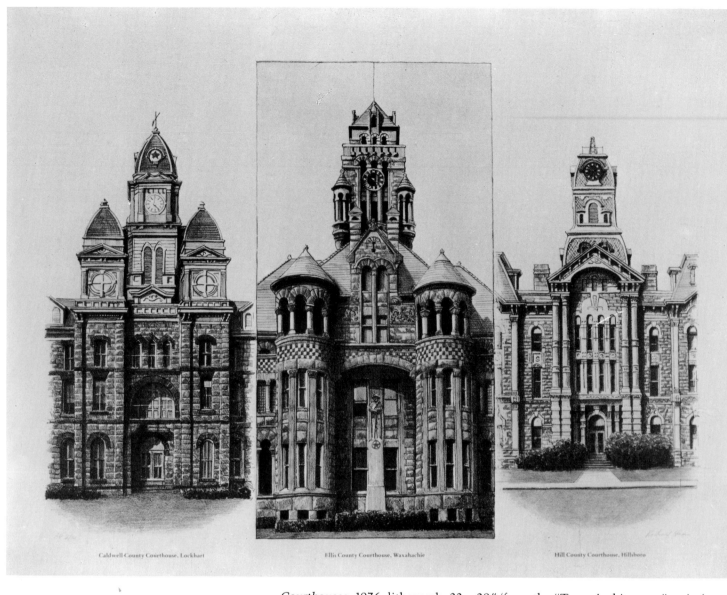

Caldwell County Courthouse, Lockhart

Ellis County Courthouse, Waxahachie

Hill County Courthouse, Hillsboro

Courthouses, 1976, lithograph, 22 x 29″ (from the "Texas Architecture" series).

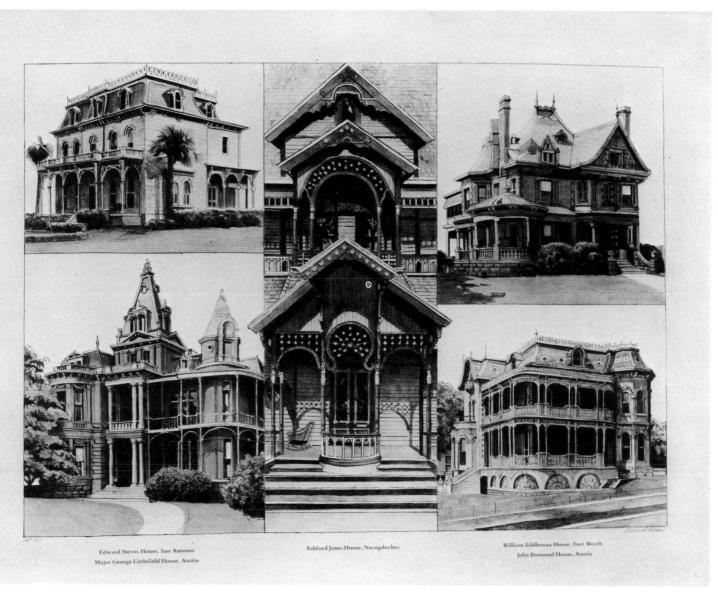

Edward Steves House, San Antonio

Major George Littlefield House, Austin

Ashford Jones House, Nacogdoches

William Eddleman House, Fort Worth

John Bremond House, Austin

Victorian Houses, 1976, lithograph, 22 x 29″ (from the "Texas Architecture" series).

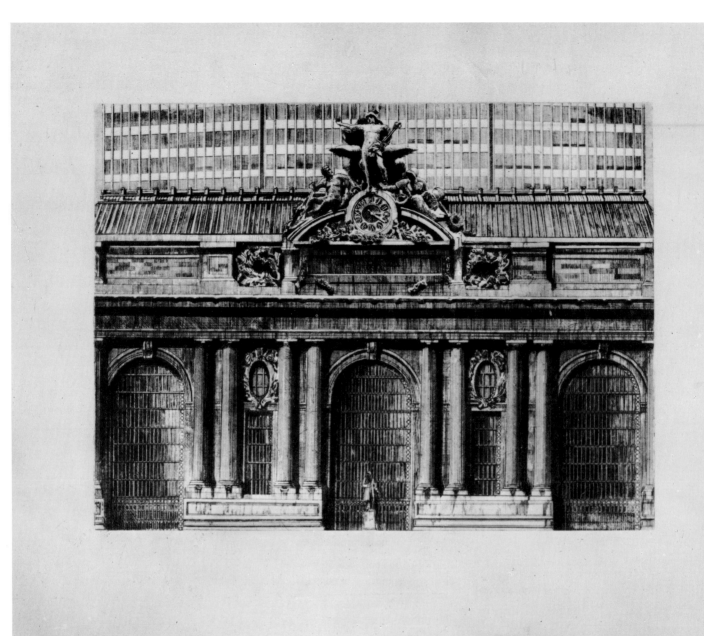

Grand Central Station, 1972, etching, 21 ¼ x 27 ¼ ".

would take six more years and many short visits before I finally would make the move.

Malcolm Myers was my printmaking instructor, and I assisted him for two years in the etching studio. Malcolm was a combination of sophisticate and naif, of cowboy honesty and directness and Parisian art taste. He had studied with Lasansky and had an intuitive feel for etching, but a very relaxed attitude toward how to approach the metal. I did few etchings while I was with him there, but I think his influence came through when I began making etchings of building facades some seven years later. The prints that I did at the time were large generalized figures in landscapes, cut roughly in wood out of drawing boards that I confiscated in night raids on the drawing studios. I was looking hard at Munch at this time, especially his woodcuts, and I also cut the boards in puzzlelike shapes to apply color in various areas.

After three years at Minnesota, I got a teaching position at Michigan State University. Teaching jobs in state universities were easy to find in the mid-sixties, as every art department was expanding. East Lansing was even further removed from the New York art scene than Minneapolis, though it was geographically closer. To get any sense of connection one either drove to Detroit, to Chicago, or did a fourteen-hour haul to New York. I went to all

three as often as I could; each trip only increased my edginess and sense of being cut off. My work was beginning to splinter in several directions. I was continuing to follow the "avant garde," now mostly as interpreted by Clement Greenberg and his followers, many of whom came to Michigan State through Charles Pollock, Jackson's older brother. Pollock had been at the school for some twenty years and had taught etching and graphic design during most of that period. He was a wonderful, inquisitive, cantankerous guy who helped keep the stimulation going.

I was, however, also beginning to make small dioramic boxes that captured, in three-dimensional perspective, the interiors of Vermeer and Van Eyck. I became intrigued by the light and space in Vermeer's paintings and reconstructed the perspective as closely as possible. The diorama was viewed through a tiny opening at one end. Eventually, I moved on to reconstructing artists in their studios in a similar manner; Giacometti in his crusty Paris atelier, Jackson Pollock standing over one of his large paintings in Springs, Long Island. These boxes and dozens of drawings done around and for them became my "closet" art form. After all, it wasn't serious avant-garde stuff and I had to guard it carefully. I couldn't justify my boxes in the avant-garde discourse with such colleagues as Charles

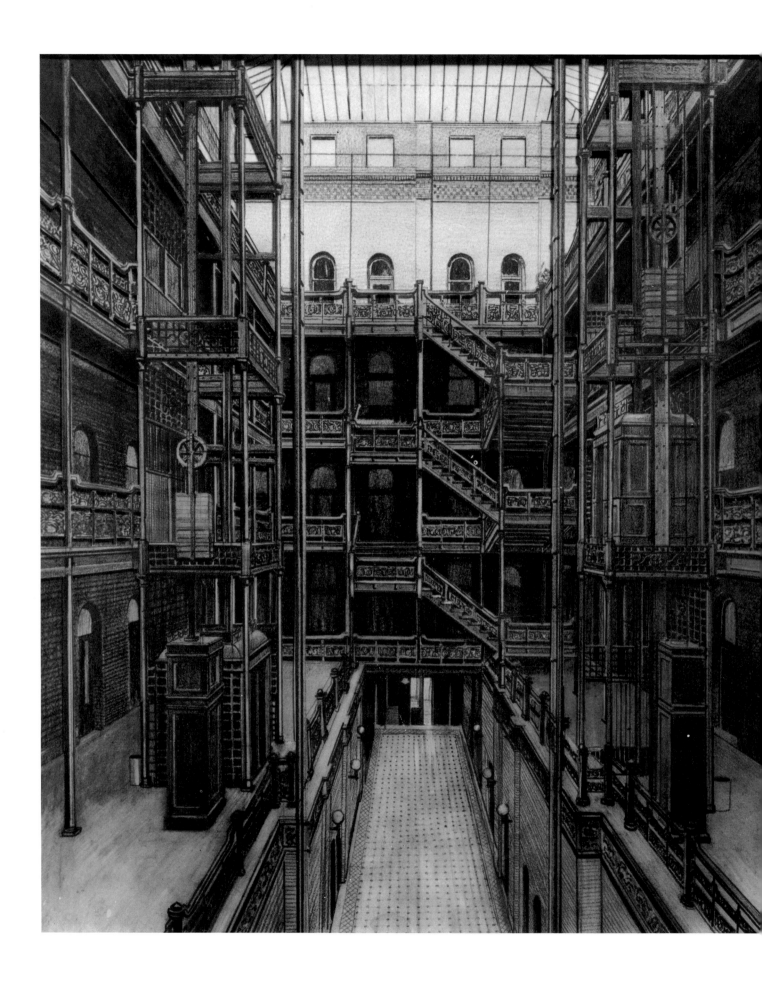

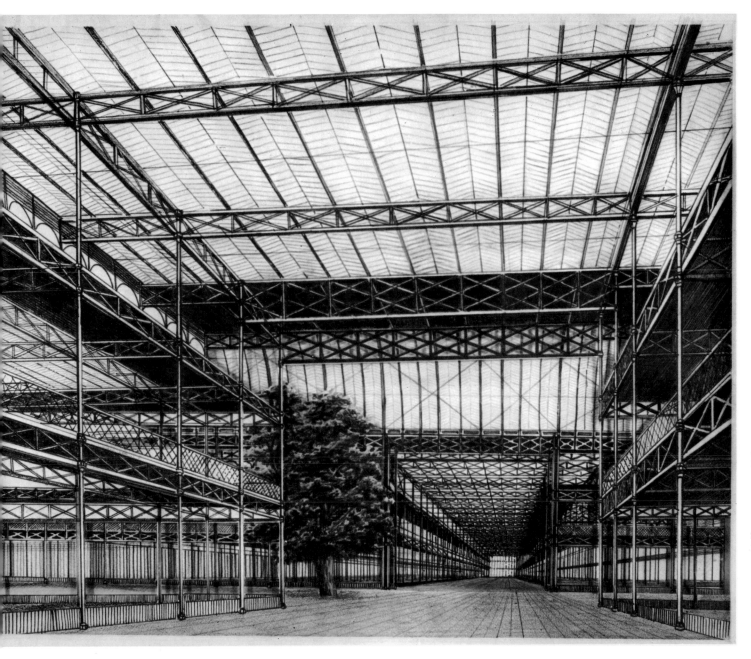

Crystal Palace, 1973, 3-dimensional drawing on paper with plexiglass, 18 x 17˝.

Lobby of the Bradbury, 1973, 3-dimensional pencil drawing on paper with plexiglass, 19¼ x 16¼˝.

47

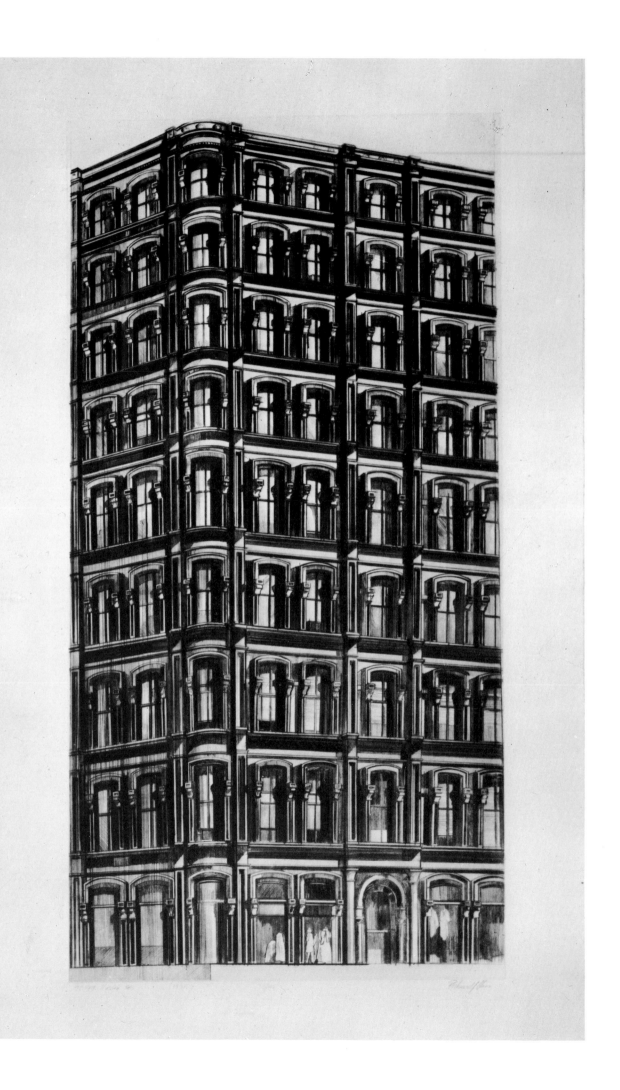

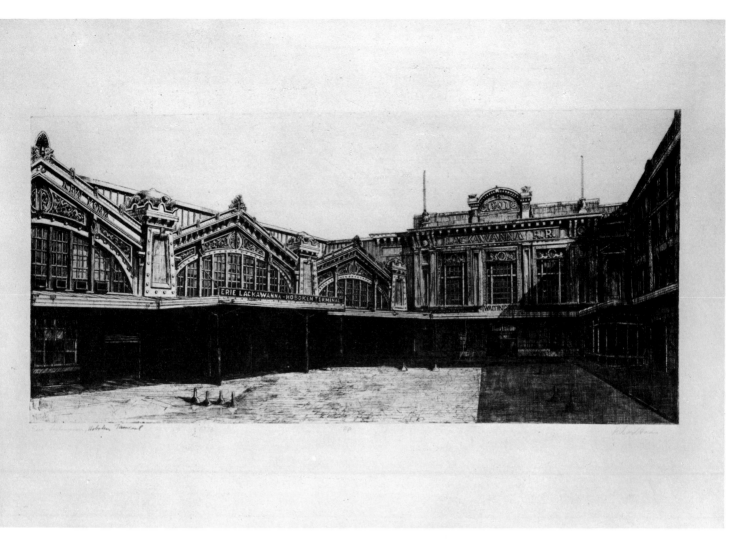

Erie Lackawanna Hoboken Terminal, 1973, etching, 21 x 36¼ ".

91-97 Nassau Street, 1971, drypoint, 38¼ x 21 7/8".

Rookery Courtyard, 1974, etching and aquatint, 22 x 23¼".

Hugh O'Neill Building, 1974, oil on canvas, 18 x 18″.

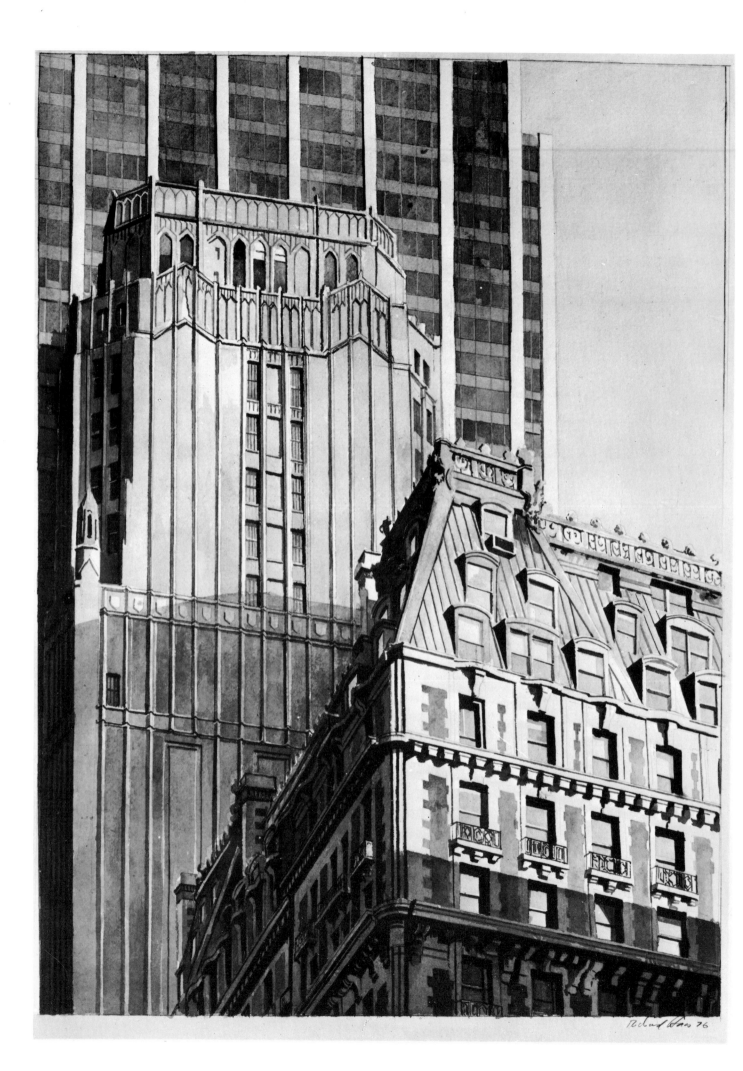

Olana, 1974, lithograph, 23¾ x 22¼".

Forty-second Street and Broadway, 1976, watercolor, 39 x 28".

View of West Fifty-seventh Street, 1978, watercolor, 26 x 33¼ ".

St. Patrick's Cathedral, 1980, watercolor, 38¼ x 20½ ".

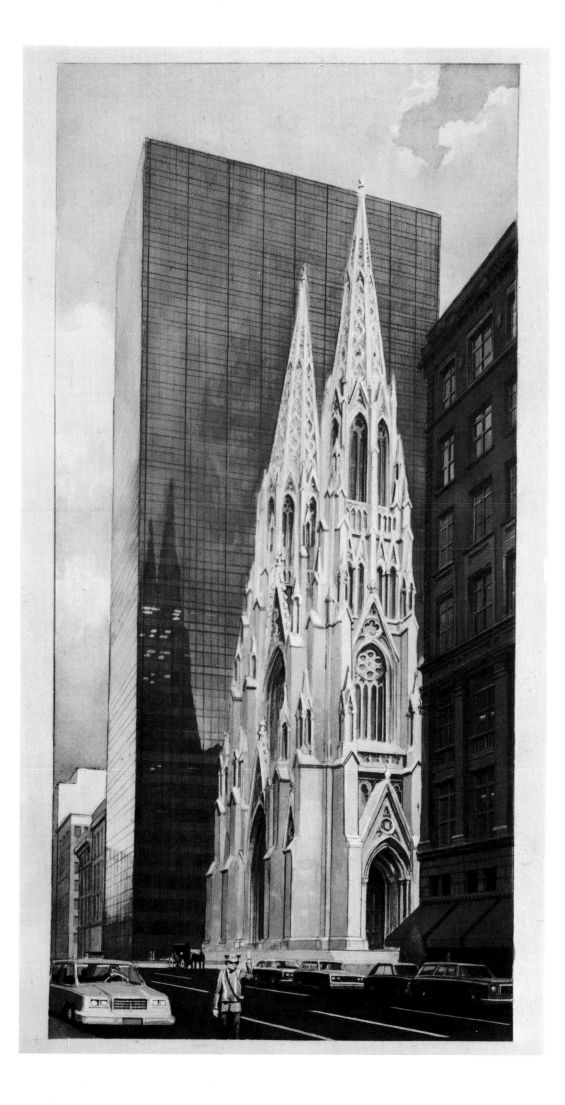

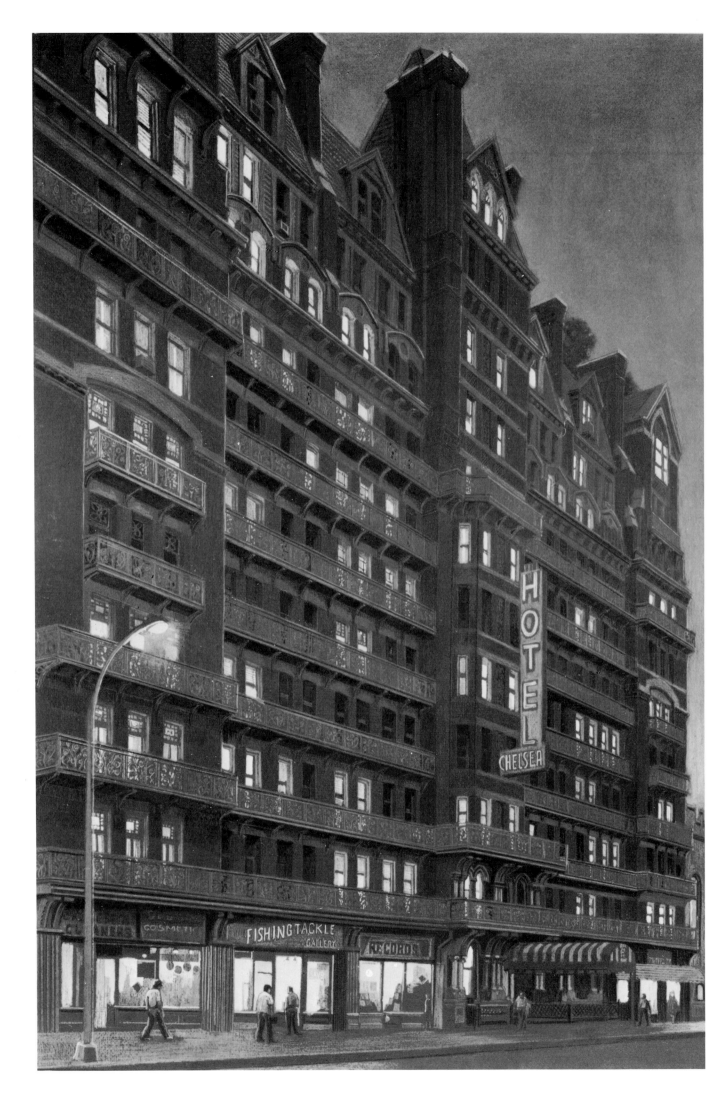

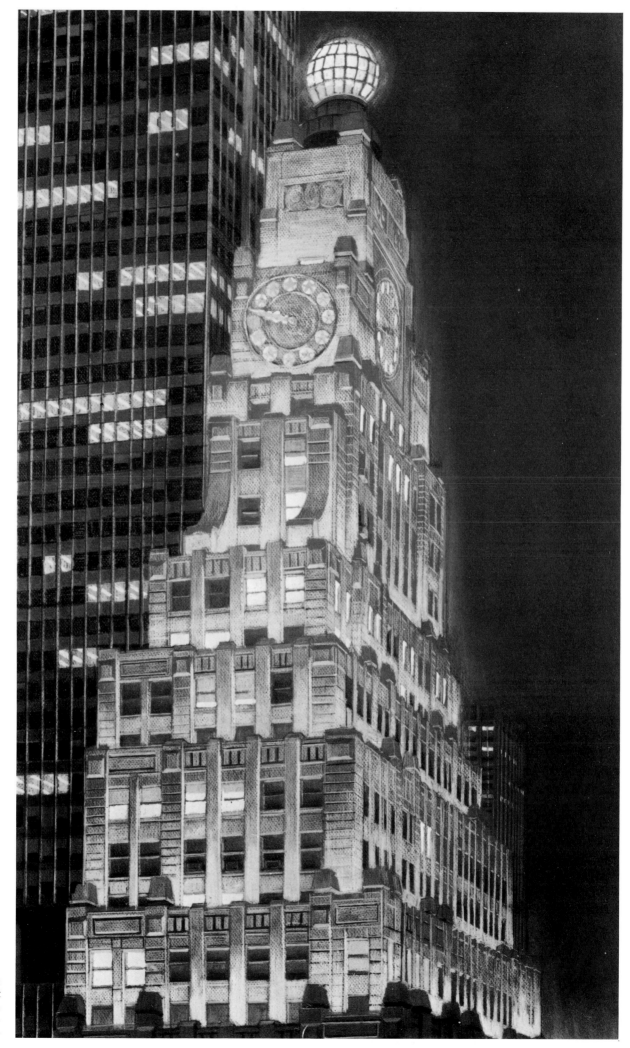

Opposite page:
Chelsea Hotel,
1980, pastel,
35¼ x 25¾".

Right:
*Paramount
Building,*
1980, pastel,
40¼ x 25".

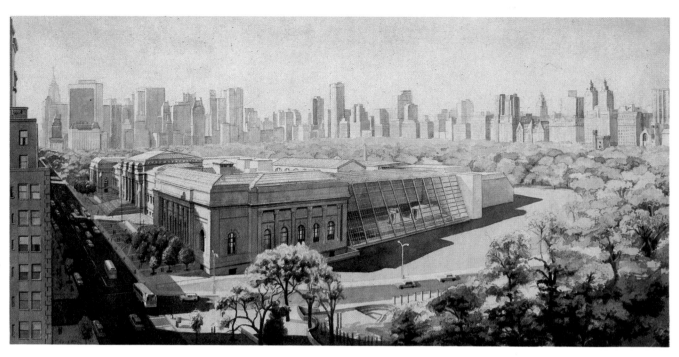

Above: *Metropolitan Museum, Central Park (Day)*, 1979, watercolor, 21¾ x 40″.

Below: *Metropolitan Museum, Central Park (Evening)*, 1979, watercolor, 21¾ x 40″.

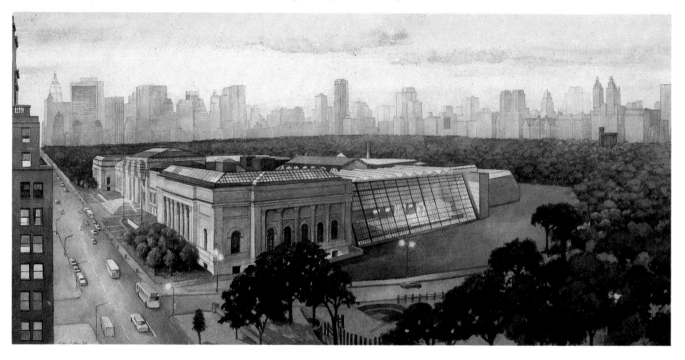

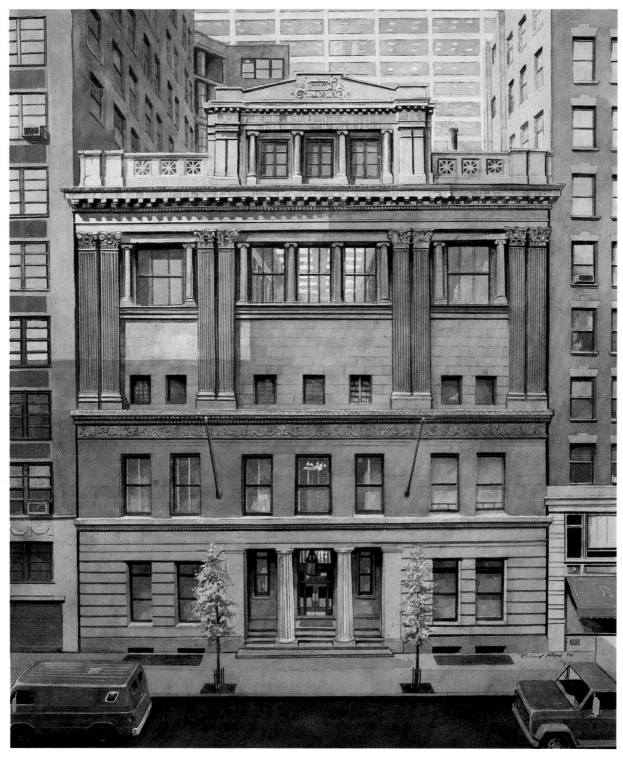

The House of the Association of the Bar of the City of New York, 1979, watercolor, 37 x 30".

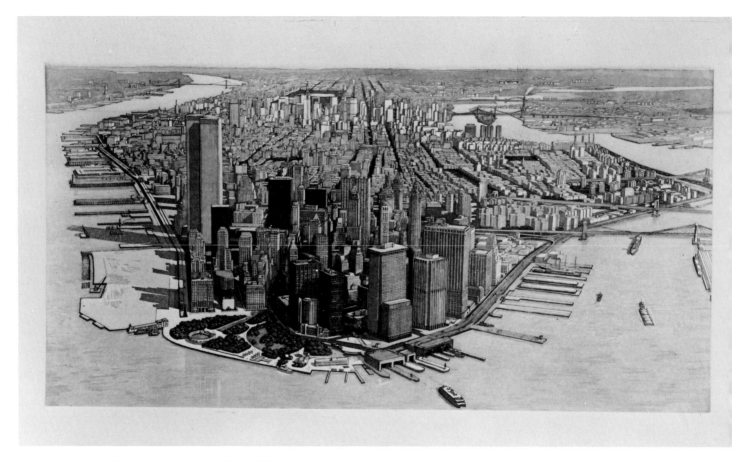

Manhattan View, Battery Park (Day), 1979-80, color etching and aquatint, 26½ x 47".

Pollock or Tom Wallace, but I was having a hell of a good time making them. The boxes involved so many of my real interests, such as art-library rummaging or capturing the details and ambience of real light and space as well as my desire to draw and record accurately. After reading Roger Shattuck's *Banquet Years*, I did a series based on early twentieth-century Paris with *Gertrude Stein in Her Dining Room* and *Apollinaire in His Bedroom*, and I created homages to my special heros in architecture in such pieces as *Louis Sullivan in the Auditorium Bar*, *Frank Lloyd Wright in His Spring Green Studio*, or *Gaudi in the Parc Guell*.

Eventually, a former Michigan State colleague, Bob Cronin, told me to apply at Bennington in printmaking, so I decided to risk going to New York. I took a one-year leave from Michigan and sublet a loft on the Bowery in June of 1968. That fall I began commuting to Bennington from New York, and I kept up this routine for the next ten years except for leaves of absence.

New York as an environment overwhelmed me at first but it immediately focused my architectural eye. After three months on the Bowery, I moved to a loft on Wooster and Broome streets, and I was surrounded by cast-iron facades on all sides with twelve-foot windows running for seventy feet. I continued making boxes, but they now began to

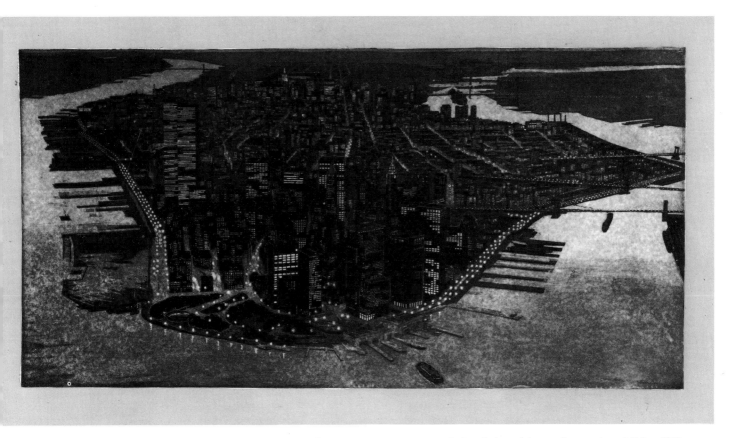

Manhattan View, Battery Park (Night), etching and aquatint, 26½ x 47˝.

reflect the SoHo neighborhood. I did two perspective views of Broome Street, one of Greene Street, one of the corner of Howard and Broadway, and several neighborhood interiors such as Fanelli's Bar and Porcelli's Meat Market.

I was commuting each week back and forth to Bennington with Sidney Tillim, whose endless "Taconic Seminars" or "On the Road Dialogues" were extremely influential at that time. Sidney has an analytic critical mind and he put much of what was going on in New York at the time into another perspective. New realism, conceptualism and earth art were the talk then as was the consolidation of several realist painters in various exhibitions at the Whitney Museum and in Milwaukee, etc. Sidney was involved with a group of artists who had just formed the "figurative alliance." Other artists included Philip Pearlstein, Gabriel Laderman and Paul Georges, to name a few. He was also associated with the artists around Bennington and the Greenberg camp. Realists felt pressured by the art that controlled the scene and needed somehow either to seek acceptance by the artists in the critical limelight, enter into art critical polemics with them, or somehow justify their existence against the modernist tradition that had prevailed for some twenty years. My running conversations with Sidney helped to consolidate and crystallize

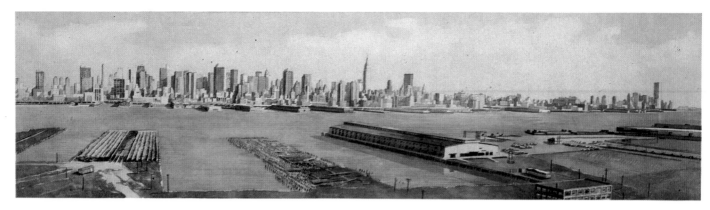

View from Weehawken, 1979, watercolor, 20¾ x 58¾".

my own thinking and allow me to stop working as a Jekyll-Hyde artist. It was almost as if I had been a modernist abstractionist by day and a private realist by night.

In early 1969 I began to make a series of five drypoints of cast-iron facades. The Haughwout Building on the corner of Broome and Broadway was the first; others included the Bayard-Condict Building on Bleecker and Donald Judd's loft on Mercer. The technique came automatically to me and related to so much I had studied over the years—etchings by Canaletto, Meryon, Haden, Whistler, Rembrandt, D.Y. Cameron and especially Piranesi. Over the next five years I collected examples by most of these artists and discovered other masters I had not known earlier. I had written papers in college on both Seymour Haden and Charles Meryon, so their work was extremely familiar to me. I continued to work on the series of facades generally seen frontally and flatly. After a year or so I began to work in etching and drypoint and then etching alone. I also incorporated color in a few, such as the *Old Staten Island Ferry* and the *New Era Building*.

Early in 1972, Frederica Hunter of the Texas Gallery asked me to come to Texas to look at Galveston architecture. She had a graphics and drawings gallery and was very interested in Texas architecture. This gave me an opportunity to study

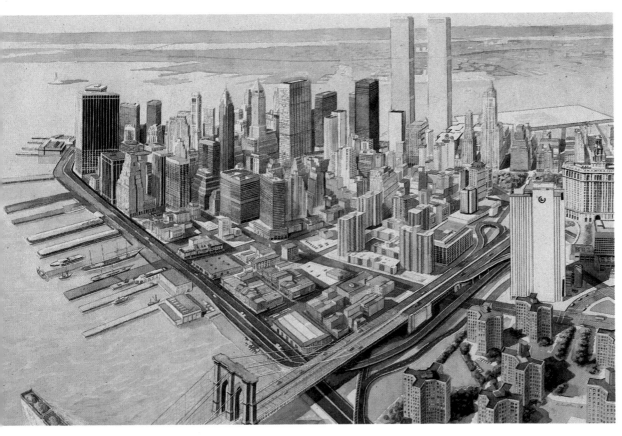

View of Manhattan, Brooklyn Bridge, 1979, watercolor, 27½ x 42¼ ".

and draw the indigenous architecture of another American region. I had already become interested in a wider range of late nineteenth- and early twentieth-century architecture in New York. I was starting to focus on the American Renaissance style in such buildings as Grand Central Station, the Ansonia, the Flatiron Building and the Custom House. In the next few years, early twentieth-century American architecture would become my dominant interest in etchings, lithographs and watercolors. I would also begin to see patterns and repetitions in the compositions of buildings on the street and become more fascinated by the clash of styles on the street. I started to work more and more in watercolor in 1973-74; many of these were of cul-de-sacs in the financial district of lower Manhattan. The city began to appear as a battle between order and chaos in the style jumbling that occurs in an area like lower Manhattan, where 250 years of architectural styles and urban scale are compressed into a couple of blocks. I saw similar clashes in other cities such as Boston, Philadelphia, San Francisco and Chicago.

I also did a series of three-dimensional pencil drawings at this time and had a small show of these at the Hundred Acres Gallery in 1973. The drawings were a series of interiors done on several layers of paper with plexiglass between each layer to give a

sense of receding depth. The subjects included the interior of the Bradbury Building in Los Angeles, Les Halles in Paris circa 1973, Paxton's Crystal Palace in London circa 1850 and the Metropolitan Museum of Art entrance hall.

My early enthusiasm for the architecture I chose to draw and paint did not begin with any preservation consciousness but it did coincide with a rising concern for appreciating and preserving the Victorian, Beaux-Arts and Deco heritage of our cities. The incredible construction of offices and apartments in the 1960s coupled with the wholesale destruction of neighborhoods through urban renewal and expressway construction left most cities devastated with gaps. What was left of the past looked precarious but often more beautiful, more human, more evidently the result of craftsmanship and care than the new. The future was rushing at us too quickly and we started to question what it would look like.

EXTERIORS

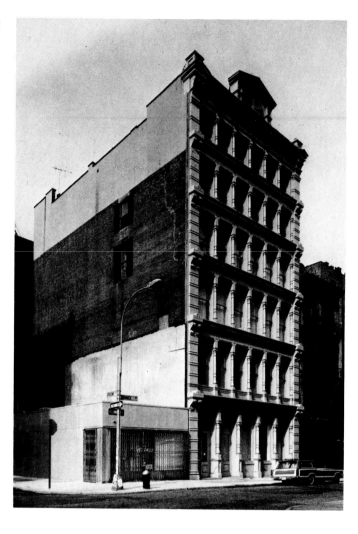

The large curtain-walled, flat-topped skyscrapers that fill the center city form backdrops for the earlier, more delicate and fanciful skyscrapers of the teens and twenties. Such early buildings as the Woolworth, the Chrysler, or the Waldorf become magical, beautiful, and soft against the harsh repetitive simplicity of their descendents. It was my observations and drawings of this urban situation that propelled me toward wanting to carry my work to the streets of the city.

Another factor that greatly influenced me between 1968 and 1974 was that I traveled extensively, especially to Europe. In southern Germany I found the delicate illusions of the rococo artists Balthazar Neumann and the brothers Zimmermann, Asam and Fischer, as well as many anonymous painted exterior frescoes. I also discovered the Italian painted villages along the Ligurian coast near Rapallo and the many fresco interiors throughout Italy by Veronese, Tiepolo, Peruzzi and others. This discovery of earlier solutions to softening the impact on the eye caused by the chaotic clashes of the city and the possibilities offered by paint for altering our perceptions of interior and exterior spaces led me to consider painting architectural illusions on blank city walls.

An organization called City Walls had been organized in 1970 by several artists including Allan d'Arcangelo, Robert Wiegand and Jason Crum under Doris Freedman's direction and had been painting large geometric murals in the city for about five years. When I took my first proposals to their office, Doris immediately liked them, especially my idea of repeating the cast-iron front of a wall on Prince Street around the corner on Greene Street, and she initiated the work that was to lead to the signpainters executing that wall some five months later. I had no knowledge of the complicated logistics of obtaining endless city and neighborhood approvals or of making contracts with signpainting companies, and it was through her office that this became possible. Had I been aware of the endless hurdles necessary to get these things done I might never have started such public projects. Each project that I have undertaken since then, whether successfully completed or not, has been loaded with anecdotes of complications and near disasters. This is automatically part of working in public space with a clientele outside the art

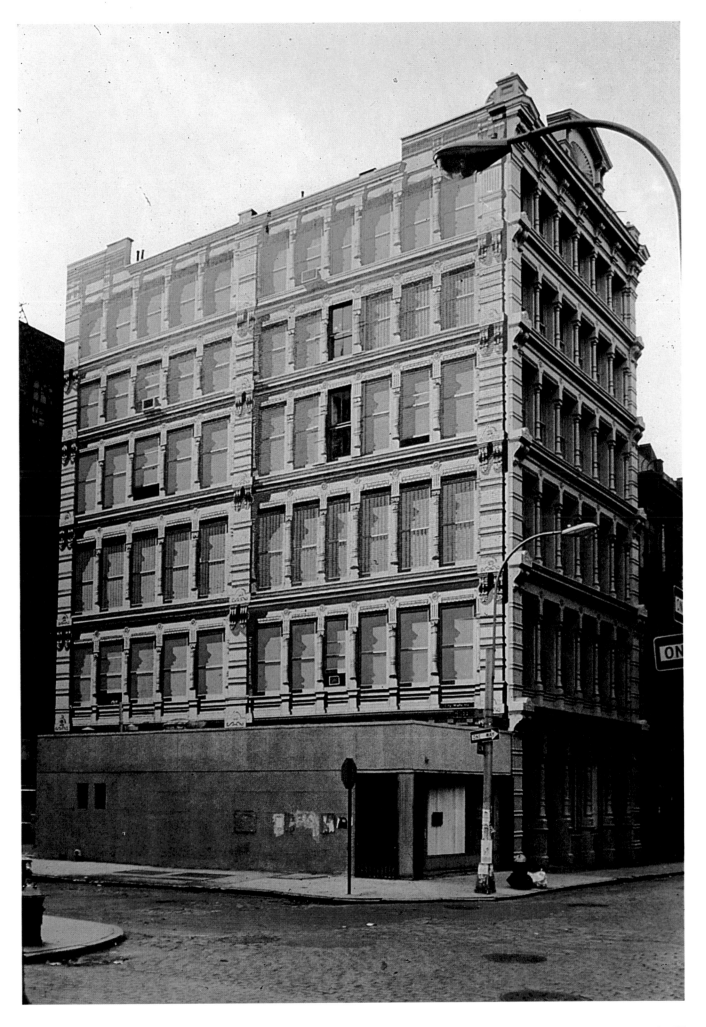

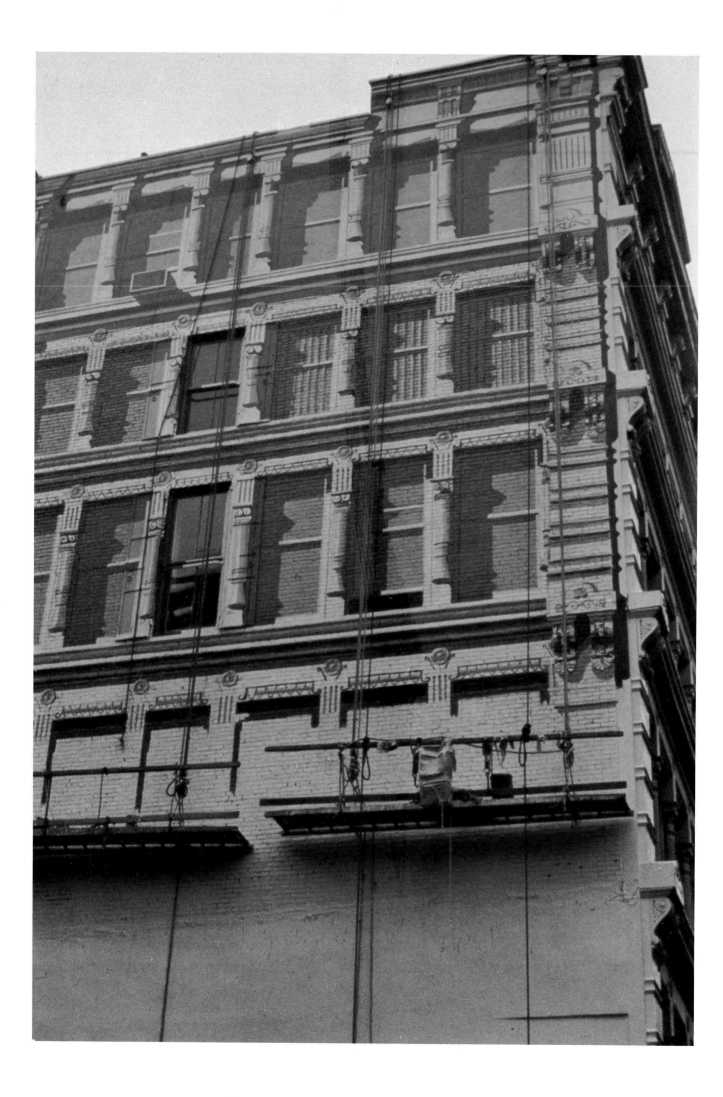

Right and opposite page: details of *112 Prince Street Facade* showing painting in progress.

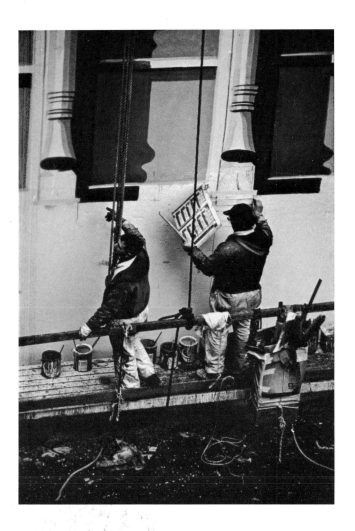

establishment. There are no clearcut principles or rules that direct me from project to project; each one is a unique problem requiring its own solution.

From the first wall project on Prince Street all of my outdoor wall projects have been executed by professional signpainters. I prefer designing work that can be translated into their range of skills, rather than executing the work myself. The most obvious reason for this is that it allows me to work on several projects rather than very few; work can also be done in different parts of the country simultaneously. My assistants and I work in the studio executing one-half inch to a foot scale drawings in colored gouache. Certain complicated details are done in one inch to a foot so they can be interpreted easily. All measurements off the wall of the building are carefully noted in the drawing. The signpainters then prime the wall and draw the work out twenty-four times the scale of the maquette. Colors that have been pre-mixed off the maquette are then applied as the second coat and the mural is completed in sections, usually from top to bottom, as a gondola scaffold is lowered. I check and supervise by trying to be on site as the project commences, again in the middle and finally as the work is being completed. My presence, however, varies from project to project and also depends on my confidence in the work of the signpainters.

Right, below and opposite page: details of
112 Prince Street Facade showing painting in progress.

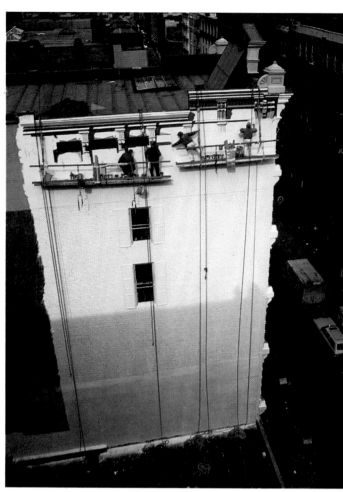

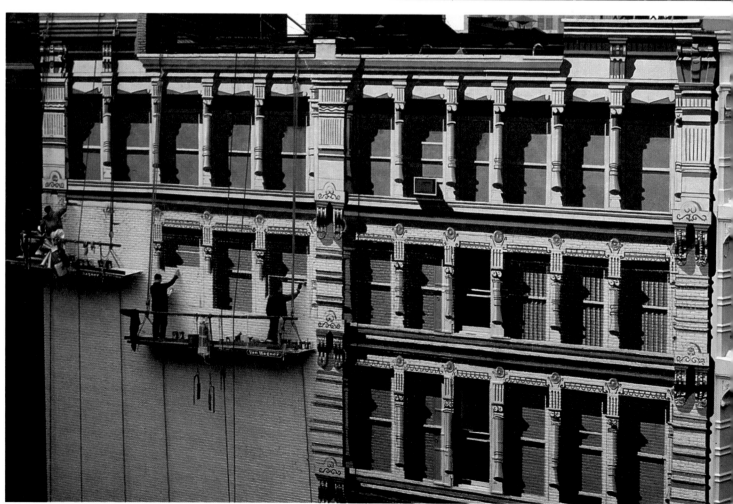

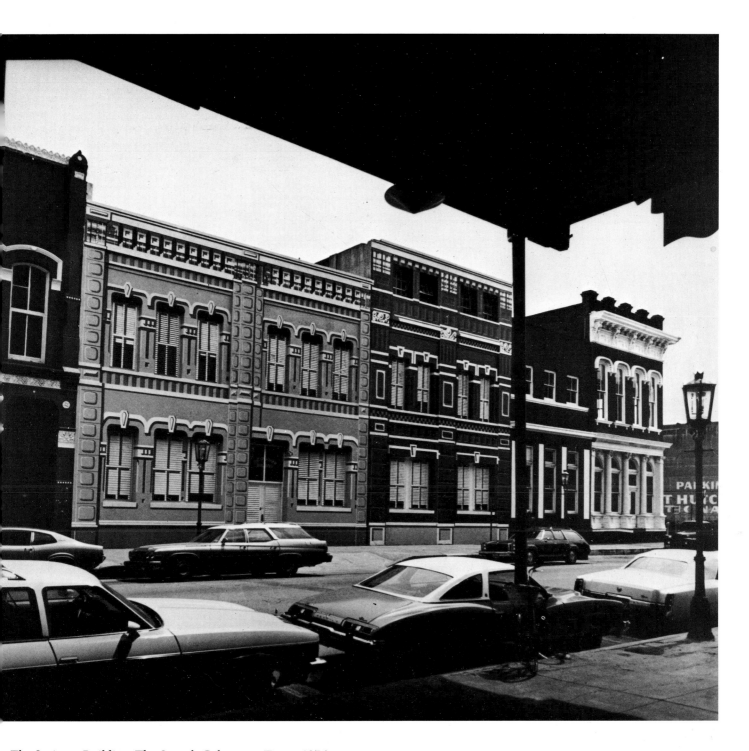

The Springer Building, The Strand, Galveston, Texas, 1976.
Commissioned by the city of Galveston. Opposite page: the
street before painting.

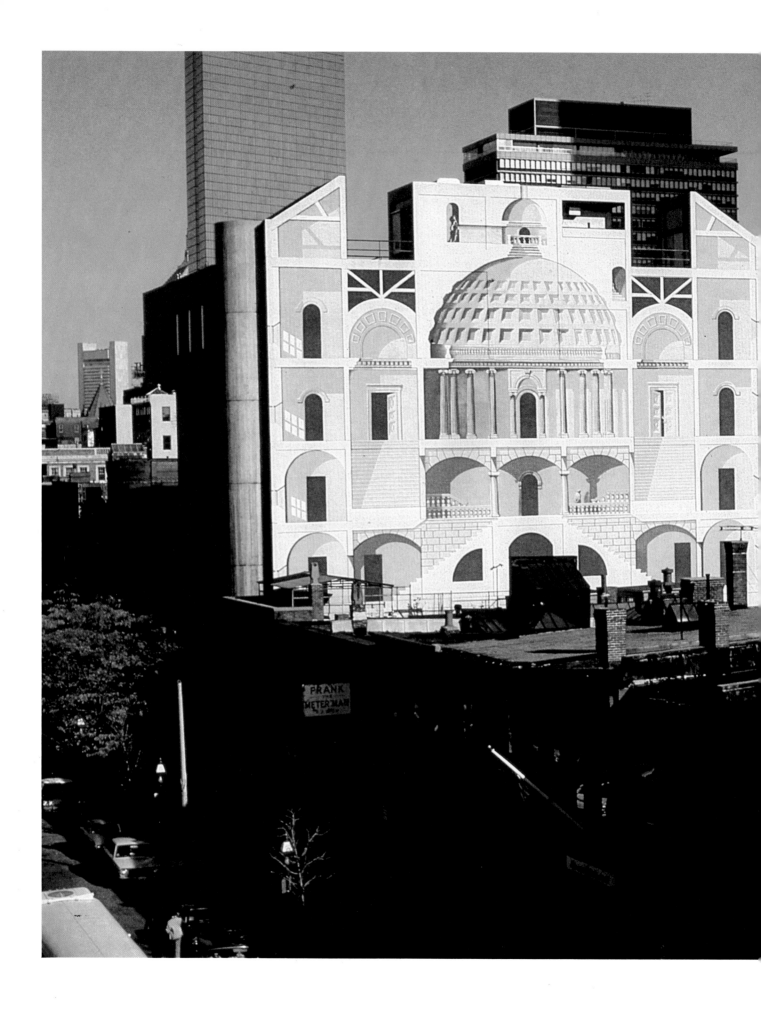

Left: *West Facade, Boston Architectural Center*, Newbury Street, Boston, 1975-77, 50 x 78'. Commissioned by the National Paint and Coatings Association; coordinated by City Walls, Inc.; executed by Seaboard Outdoor Advertising. Above: the original wall.

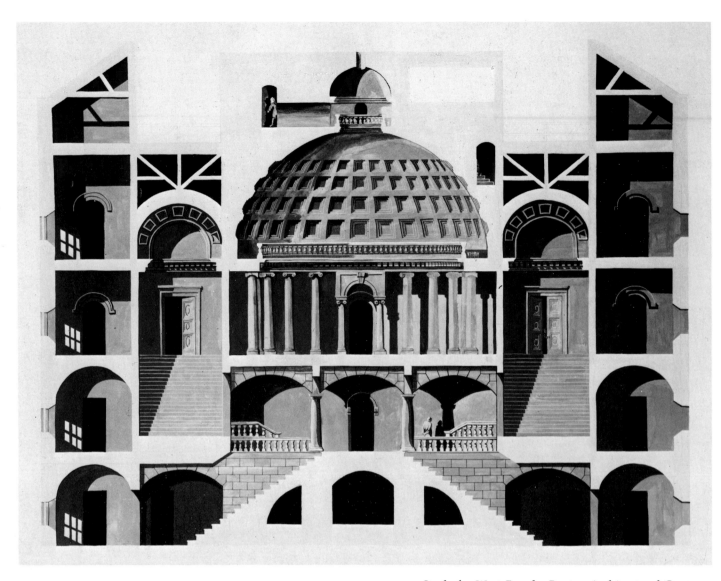

Study for West Facade, Boston Architectural Center,
1976, gouache on paper, 36 x 50½ ".

Study for West Facade, Boston Architectural Center
(early phase), 1975, collage, 29¾ x 27½ ".

76

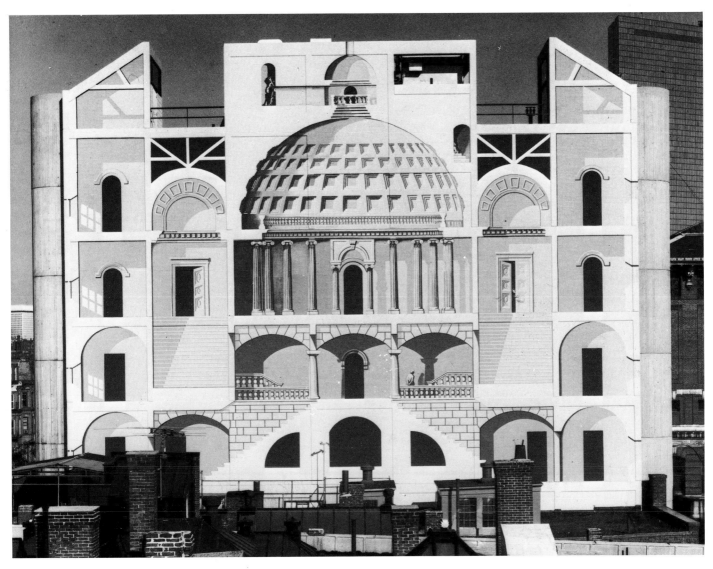

West Facade, Boston Architectural Center, completed.

Etienne-Louis Boulleé, *Cross-section of Museum*, 18th century, ink and wash drawing.

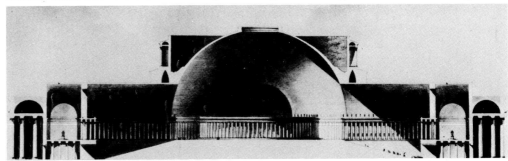

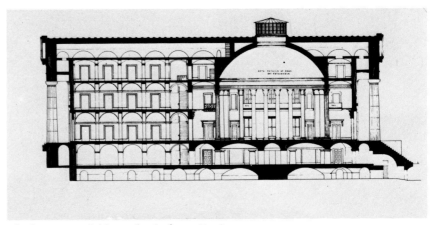

Ithiel Town and Alexander Jackson Davis,
United States Sub-Treasury, New York, 1832-42 (section).

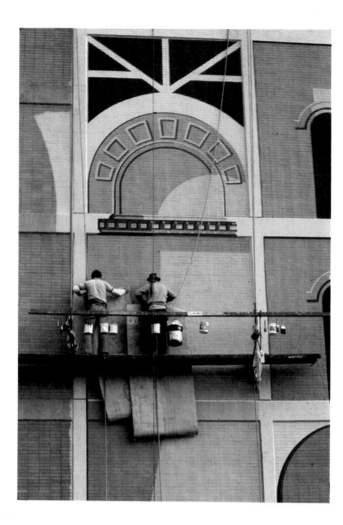

Left: detail of *West Facade, Boston Architectural Center* showing painting in progress. Opposite page: the completed mural.

Shortly after completing my first wall I began to see many other possibilities. My first shadow proposals, such as the one placing the shadows of the Empire State and Chrysler buildings one-to-one on the World Trade Center, or Madison Square Garden tower's shadow (by McKim, Mead & White), on a wall near Twenty-third Street and Park Avenue South, were done in early 1975. These were the first of many hypothetical projects that continue to this day and which I will discuss later.

The small pair of shops on Mulberry Street between Grand and Hester began when Doris Freedman of City Walls worked with LIRA (Little Italy Risorgimento Association) to help in the upgrading of the old Italian district. I can remember meetings where the members of LIRA wanted assurance that some of the artists would be Italian. I assured them that they would be, as many of the signpainters I used were Italian. I studied several books of photographs at the time, especially the work of Bernice Abbott, who had documented Little Italy extensively in the 1930s, and I focused on one of her photographs of the Sanitary Bakery with the typical lower stairway to the bakery. The lawyers' office simply seemed appropriate subject matter for the block, as it had ambiguous and possibly sinister connotations.

In late 1975 Peter Brink, a lawyer for the Galves-

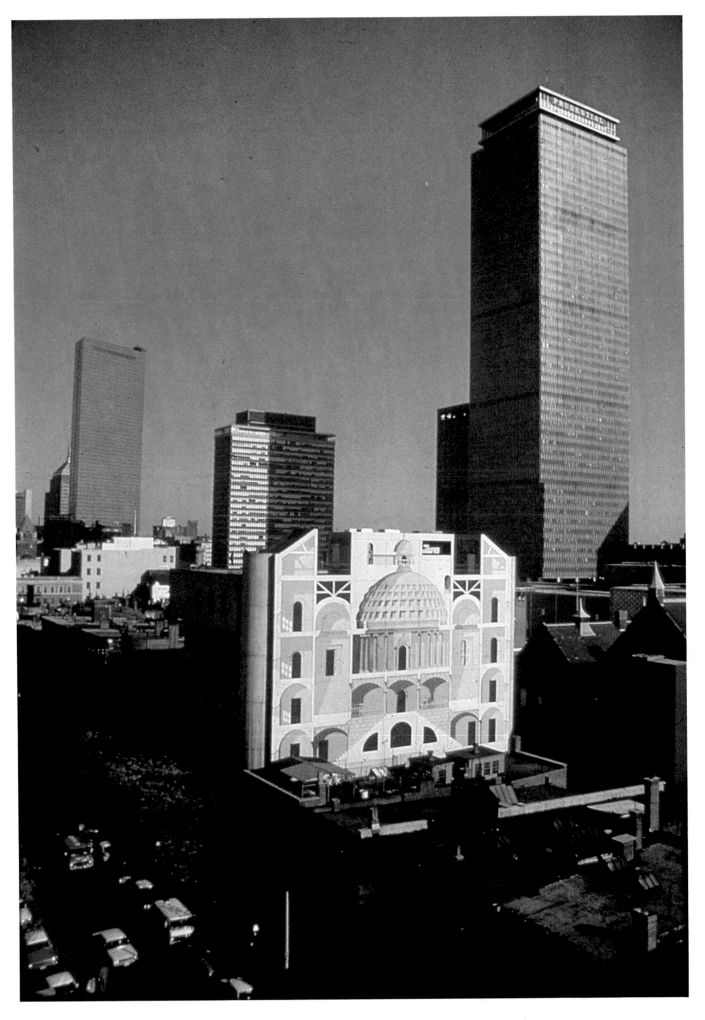

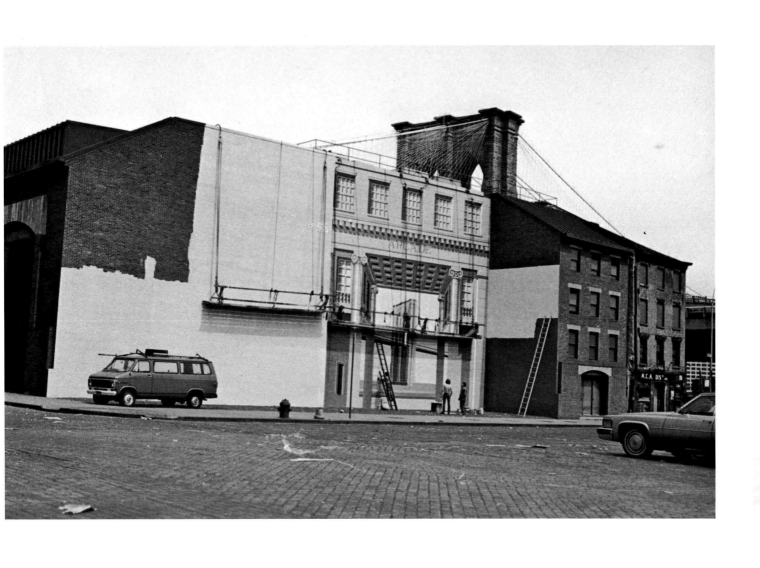

Arcade, Peck Slip, South Street Seaport, New York, 1977-78, 52 x 110'. Commissioned by Consolidated Edison; coordinated by City Walls, Inc.; executed by Seaboard Outdoor Advertising. Opposite page: Consolidated Edison substation before painting; above: painting in progress; overleaf: the completed mural.

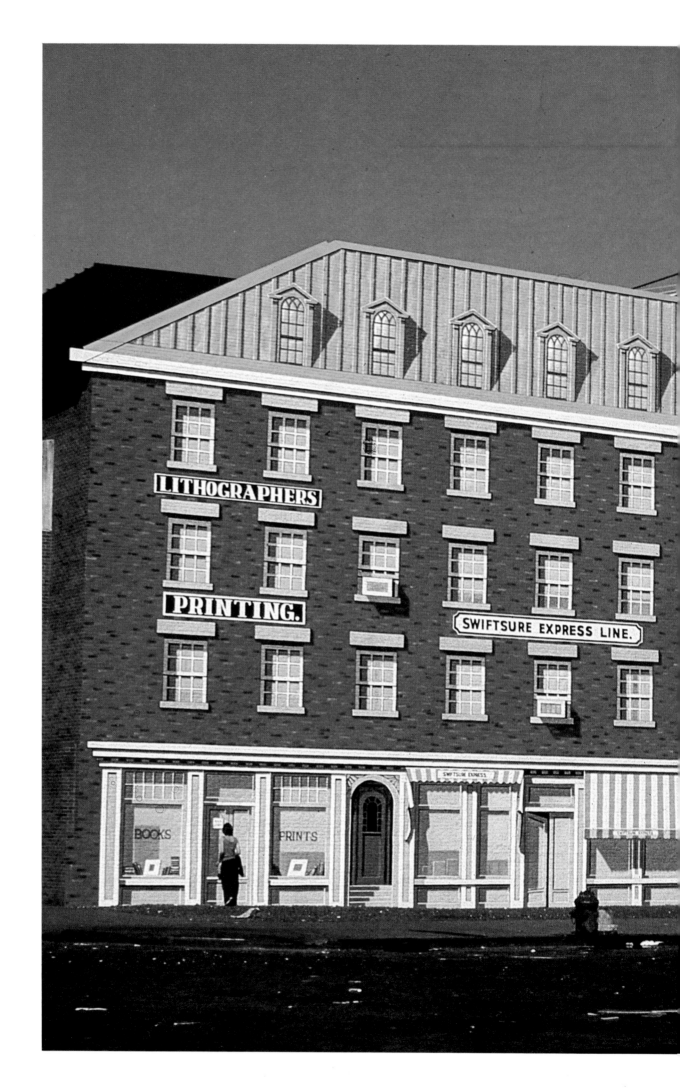

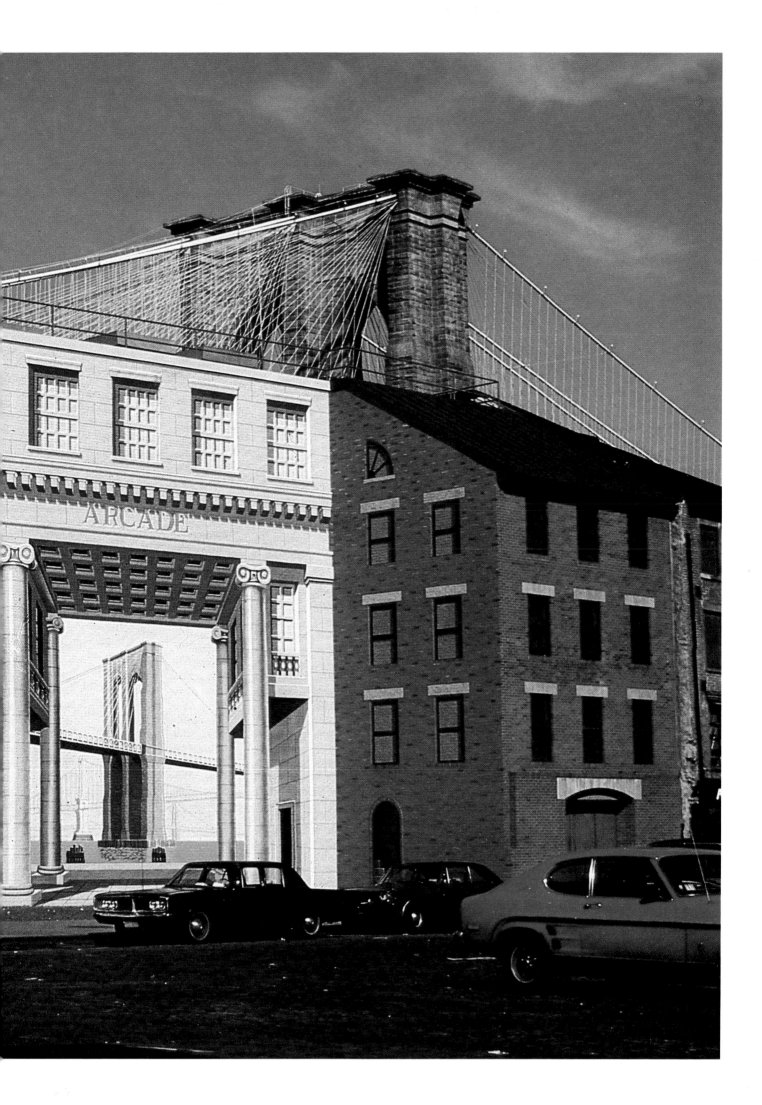

ton Historical Foundation and a strong advocate of revitalization of old urban areas, asked me to look at the Strand, which was the old main street of Galveston in the late nineteenth century. I had, as I mentioned, worked there before doing a series of prints in 1971-72. Venturi and Rauch had studied the street and made a proposal for it and they suggested that I be called to treat the Springer Building. I studied the building and its history and found that it had originally been two buildings; as with most Galveston buildings it had shrunk after losing its top in the great 1901 hurricane that nearly destroyed the entire city. I also decided to include more elements of Nicholas J. Clayton, who was the major architect of Galveston's late Victorian era.

My next project was a cross-section cutaway view for the rear wall of the Boston Architectural Center. The idea for the design came from a whole history of architectural drawing, especially Beaux-Arts drawing. This design preceded the Museum of Modern Art's show of 1977 and was inspired by Prix de Rome books I had collected over the years. The cutaway seemed appropriate for an architecture school facade and it also allowed me to pay homage to the eighteenth-century visionaries Boullée and Ledoux. The problem was how somehow to lock this fantasy onto the back of a 1960s ''brutal'' style building. The symmetry and mass of the rear wall with its rounded stair towers on either end initially led me to the concept of an eighteenth-century section. I chose to retain the module of the supporting members which were ten feet square and only after several trial sketches did I decide to open up a large central rotunda. I was encouraged in this by Peter Blake, who was director of the school and partial sponsor of the project.

In the Boston mural as on the Prince Street facade, I decided to include an aspect of life. The only life touch on the Prince Street facade was a cat sitting on a second-story windowsill. In the Boston piece one figure broods on the second floor; another peeks through the door at the head of the grand staircase; and a third comes around the top stair passage above the cupola, holding a lantern. These human intrusions are meant to be ambiguous, adding a footnote of intrigue and human focus to the architectural format.

I feel that a quality of ambiguity is necessary if the murals are to work. In spite of my intention to lock the paintings as tightly as possible into the wall and the architecture that surrounds it, I also feel that there must be an additional element in the mural, allowing the viewer to bring his own fantasies and illusions to the piece. This is a hidden battle that occurs in designing a piece and in different degrees in each design. I like to add narrative

Opposite page: *Arcade, Peck Slip*, view from above showing Brooklyn and Manhattan bridges in background.

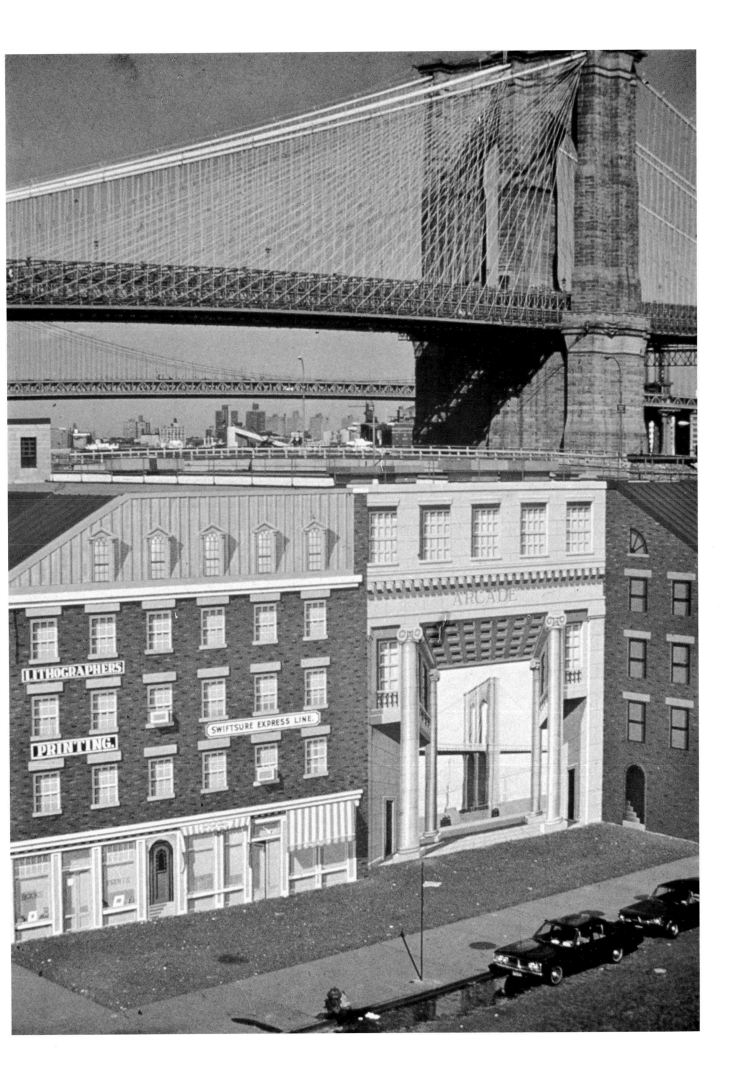

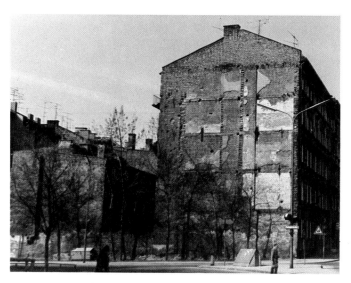

Munich Facade Near Isartor, 1978. Commissioned by Lloyd Insurance Company and the city of Munich; coordinated by Galerie Biederman. Above: the facade before painting. Below: study for *Munich Facade Near Isartor*, 1978, gouache on paper, 30 x 19".

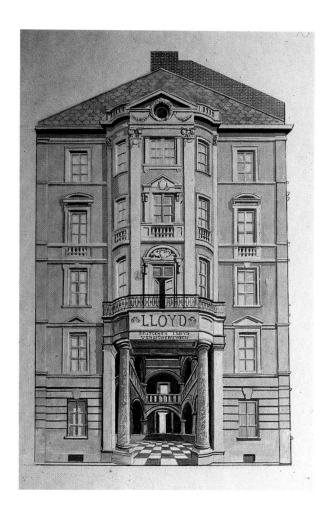

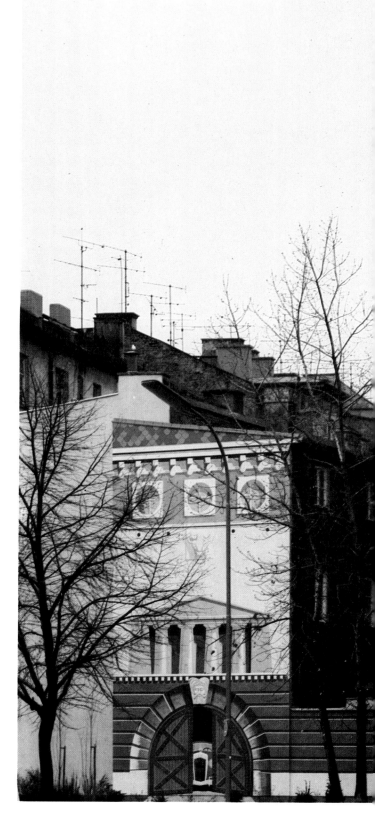

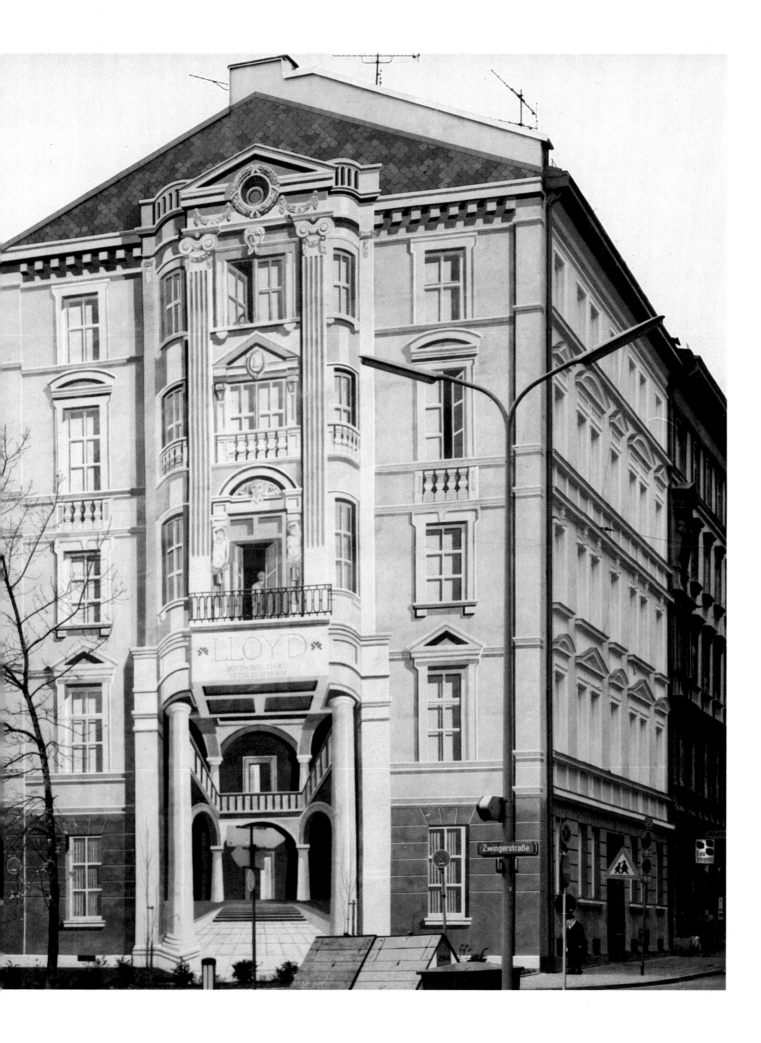

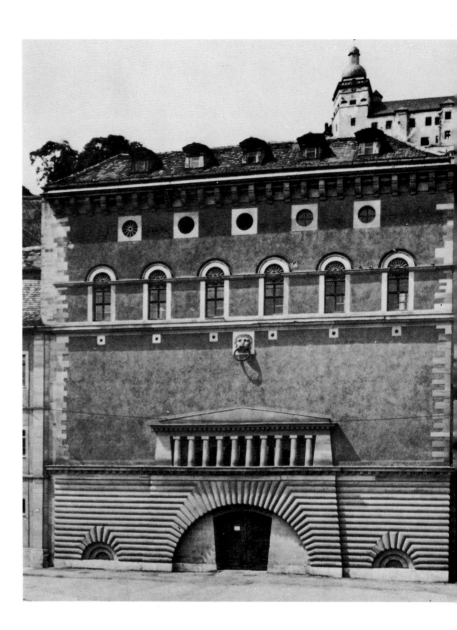

Peter Speth, Former Women's Prison, Wurzburg, 1809-10. The Haas carriage house facade (opposite page) was designed after the prison.

content where it seems appropriate.

My designs for both the Isartor facade in Munich and the Peck Slip facade in Lower Manhattan have many overtones of this nature. I began work on the Munich facade after a trip there in 1976 to look at various sites for a possible wall. Margaret Biederman, who has a gallery there, and her uncle Walter Bareiss, an international collector and art patron, began the two-year process that led to painting the wall near the Isartor in central Munich. The wall was a remnant left from the World War II bombings. A street was cut through in the early 1970s which made the wall a very visible end to a block. With help from another Munich friend, Dieter Herzog, and his Lloyd Insurance Company connections, we acquired both the wall and a backer. I returned in May of 1977 and studied the site more carefully. I also studied Munich's nineteenth- and twentieth-century architecture during this trip and did several watercolor studies of streets and facades. My choice of a facade with a large entrance court was an amalgam of this study process. I always have to familiarize myself thoroughly with the indigenous

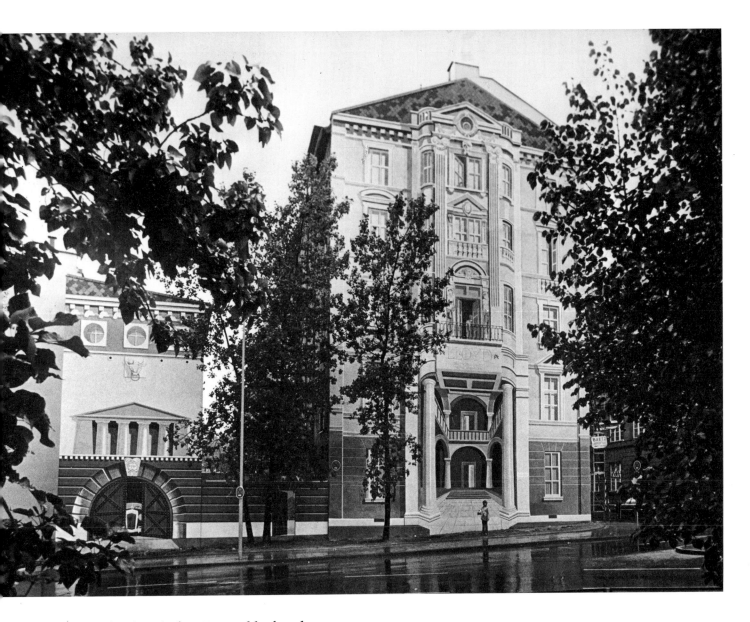

architecture of a place before I can add a facade to an environment with its own specific history, texture, color and scale. I chose a made-up version of a late nineteenth-century townhouse. The lower two floors were opened up to see into a deep courtyard, more sixteenth century in feeling, a reminder of typical earlier courtyards. Over the door, the name of the company that donated the money for the project is incised in Roman letters; this seemed a tasteful way of justifying its expenditure. The scale and window treatment echo the actual front of the apartment house around the corner to the right of the facade. Since the city of Munich paid for a portion of the facade, because it owned the property adjacent to the wall, there was enough extra money to treat a small facade to the left of the first one. While work was proceeding on the actual painting I worked in Munich on a design for the smaller facade. The neoclassical Women's Prison of Wurzburg was chosen as the theme; it was scaled down in size to accommodate the forty-foot-high building and was colored to match the larger facade. I chose to turn it into a carriage barn-garage structure with

posite page, top left: Adamschlossl, Munich, facade
nted by K.D. Assam, 1730.

posite page, top right: Schackstrasse 2, Munich, facade
Leonhard Romers, 1895-97.

posite page, bottom: house with decorations by Hans
lbein the Younger, Basel, Switzerland, 1520-23 (drawing
H.W. Berlepsch, 1875).

Above left: *Amalienburg, Munich*, 1977, watercolor, 22 x 31".

Above right: *Munich Jungenstijl Dormers*, 1978, watercolor,
image size 9 x 13".

Below: *A Street in Schwabing, Munich*, 1977, watercolor, 22 x 31".

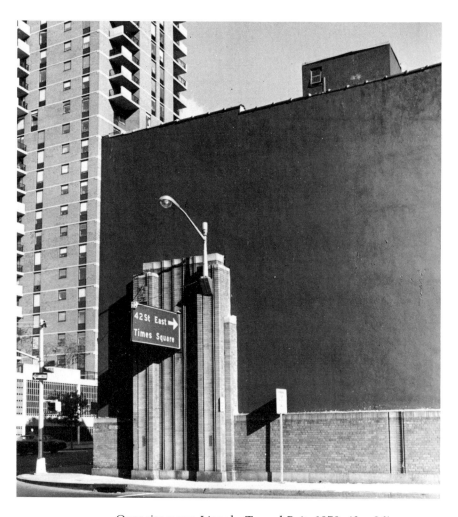

Opposite page: *Lincoln Tunnel Exit*, 1979, 42 x 96'.
Commissioned by the 42nd Street Development
Corporation; executed by Van Wagner Outdoor Advertising.
Above: the wall before painting.

the doors opened slightly to reveal a 1932 vintage
Mercedes. If I had been allowed I would have pro-
ceeded down the street and completed the entire
block of blank facades, but as with most projects,
funds were limited. It took over six months to
obtain the necessary approvals from the *Denkmal-
schutz* (landmark preservation department), which
controls all improvements and changes in historic
districts throughout Germany. There were, for in-
stance, three small trees that we wanted to remove
from the area adjacent to the wall along the side-
walk. Several meetings were necessary before ap-
proval was obtained, and then after the project was
completed, the city insisted on replanting the trees.
Also the *Denkmal* people insisted that we use Keim
Historisch paints, which after many discussions

with the signpainter we agreed to do. This turned
out to be the most fortunate discovery of the entire
project, for this silicate-based paint not only exists
in several hundred exquisite colors, but has a life
expectancy of up to a hundred years. It also has a
skin that resists pollution. Since Munich, I have
insisted on using the Keim paint whenever I can,
though there are no American outlets for it.

In late 1977, Chairman Luce of Con Edison asked
Doris Freedman's office to find someone who
might paint the side of a new substation at Peck
Slip near the South Street Seaport, designed by the
firm of Edward Larrabee Barnes. Mrs. Freedman
suggested a four-way contest of artists who for a
very nominal fee would execute proposals for the
building. My proposal was accepted. I felt that the

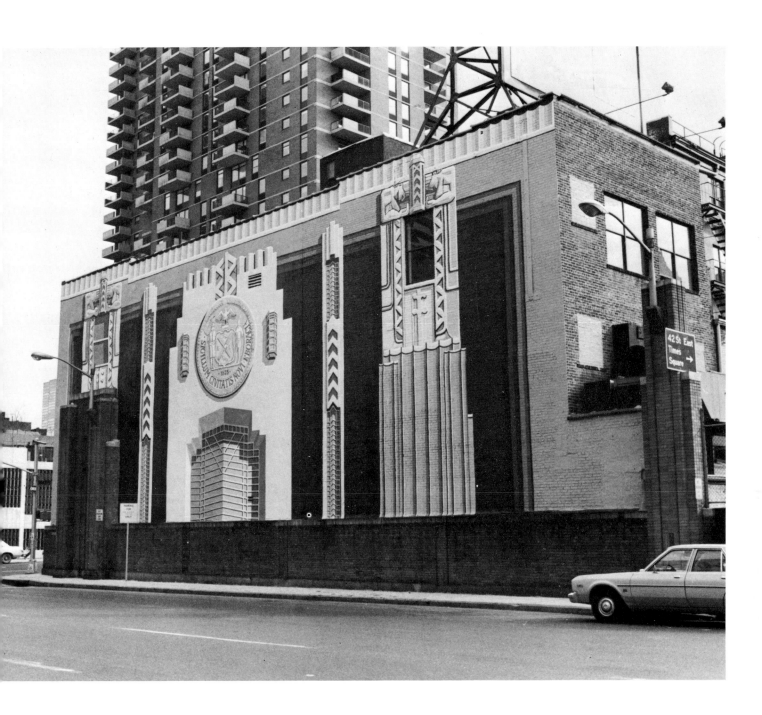

continuity of the old Federal building left on the eastern edge of the building should be respected, but that a dramatic break should occur in the middle of the block. I then chose a Greek Revival Arcade that saw through the block to a slip and then the bridges seen behind the substation, with the grand Brooklyn Bridge front and center. Immediately to the west of this edifice were two more Federal buildings with shops that completed the block. All of this tied the square formed by Peck Slip together as a sort of piazza. I was especially amused when I presented my plan to the Landmarks Commission, which objected not to the painting of a substation, but mostly to putting Greek Revival next to Federal style buildings. They agreed, however, to approve the project.

In 1978 I was appointed by Fred Papert and Joe Morningstar of the 42nd Street Development Corporation to consider two walls at the intersection of Dyer Avenue and Forty-second Street. This junction formed an entrance and exit of the Lincoln Tunnel, and I thought of the piece as a form of ceremonial city gate. The buildings that comprised the Theatre Row on either side of Dyer Avenue were a jumble of nineteenth- and twentieth-century low facades of no distinctive style. They were painted mostly with a deep brown overall. I decided to emphasize the Art Deco style suggested by the pylons at the entrance to the tunnel. On the east side, my design included a fifteen-foot seal of the City of New York with two windows on either side framed by figures in the style I call "Horn & Hardart

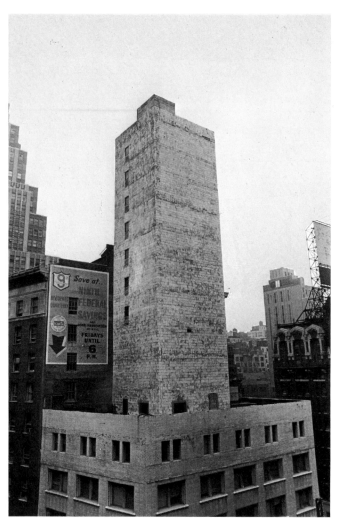

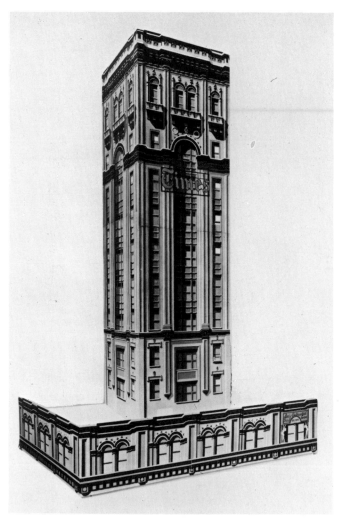

Crossroads Building, 1465 Broadway at Forty-second Street, New York.

Design for mural on tower and parapet of the Crossroads Building.

Opposite page: *The Times Tower*, 1465 Broadway, New York, 1979, 130 x 28 x 28'. Commissioned by the 42nd Street Development Corporation; executed by Artkraft Strauss Sign Corporation.

1930s." A large window below the emblem was Art Deco, but Frank Lloyd Wright-like as well. The design for the other side, which has not been executed yet because of a fire in the building, will echo the large emblem on the east side. This emblem, however, will be the emblem of actors, Comedy and Tragedy, and it is taken from a terra cotta piece on the side of Radio City Music Hall.

While consulting with Fred Papert about the work on these two projects, I noticed the tower of the Crossroads Building on Forty-second Street and Broadway. I asked him who owned the building and he said that their corporation did. I was attracted to the building because it is an enormous tower 130 feet tall and 28 feet square. It had only small windows on the east side and was otherwise solid cinderblock. The building had apparently been thrown up in 1906 by the owners to retain air rights, since the laws were being changed at that time.

I knew from the start that I needed a tower and somehow Giotto's campanile adjacent to the Cathedral of Florence stuck with me. Then I focused on the building in front of the Crossroads which had originally been the New York Times Tower and later the Allied Chemical Building. This building was always a favorite of mine, but unfortu-

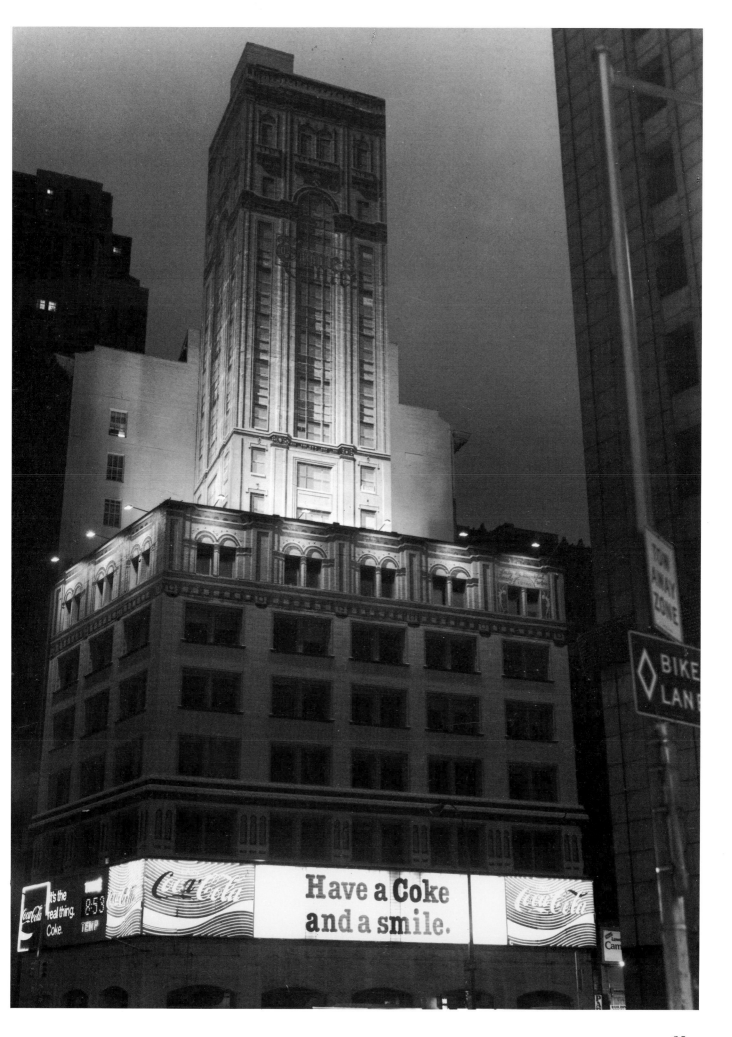

95

nately it lost its skin in the early 1960s. Originally it was a slender beauty in the manner of Giotto's tower, what I would call Italian Gothic, and all in terra cotta. It was briefly the tallest building in the world if measured from sub-basement to the top of the flagpole and was certainly the tallest building in that part of town around the time that it was built. I felt that the echo of that building had to return somehow and tried very hard to fit the spirit, if not the exact detail, of the Times Tower onto the Crossroads tower. I included the cornice and first row of windows below the tower itself in my design and eventually, with the help of the 42nd Street Development Corporation and grants from Marine Midland Bank, completed the painting of the entire building in a unified color scheme and lit the tower at night. The signpainters took over six months to complete the job and lost a great deal of money in the process. There is a small advertisement on the northwest corner of the lower portion that says, "Lady Be Beautiful Beauty Parlors, est. 1906." This is from an Andreas Feininger photo of a sign that existed on Forty-third Street and Broadway in the 1940s. The work is mostly unnoticed by passersby since it is so high up on such a busy intersection. We had a lighting ceremony with Jackie Onassis pulling the switch; the press, however, didn't show up for this occasion because there was a huge fire down the street at the same time.

I have since seen blueprints from the office of Henry Ives Cobb that show what the tower was supposed to look like as a finished gothic tower. I found them after I completed my proposal and it was only coincidental that the original design echoed my own. The gothic design for the Crossroads tower was meant to echo the Times Building tower directly north of it in style. I do not know why this design was never carried out and why the tower was left unfinished for seventy years.

Donald Young and Rhona Hoffman of the Young Hoffman Gallery in Chicago had been trying to arrange several projects in Chicago since they had shown my work in 1978. Ben Weese and his firm had been working with two developers on a project at the corner of LaSalle and Division streets. It was a building twenty stories high with a completed facade facing west and three incomplete facades facing south, east and north. The east side included about 200 windows and the north and south facades included windows to be bricked up. The total surface available for painting was over 80,000 square feet. I knew I wanted to lock the front color and design to the other three sides, but the new design would dominate and the original become subordinate. The reason I felt that I could subordinate the eclectic west facade was that it would become the

Opposite page: *The Times Tower* (detail showing painting in progress).

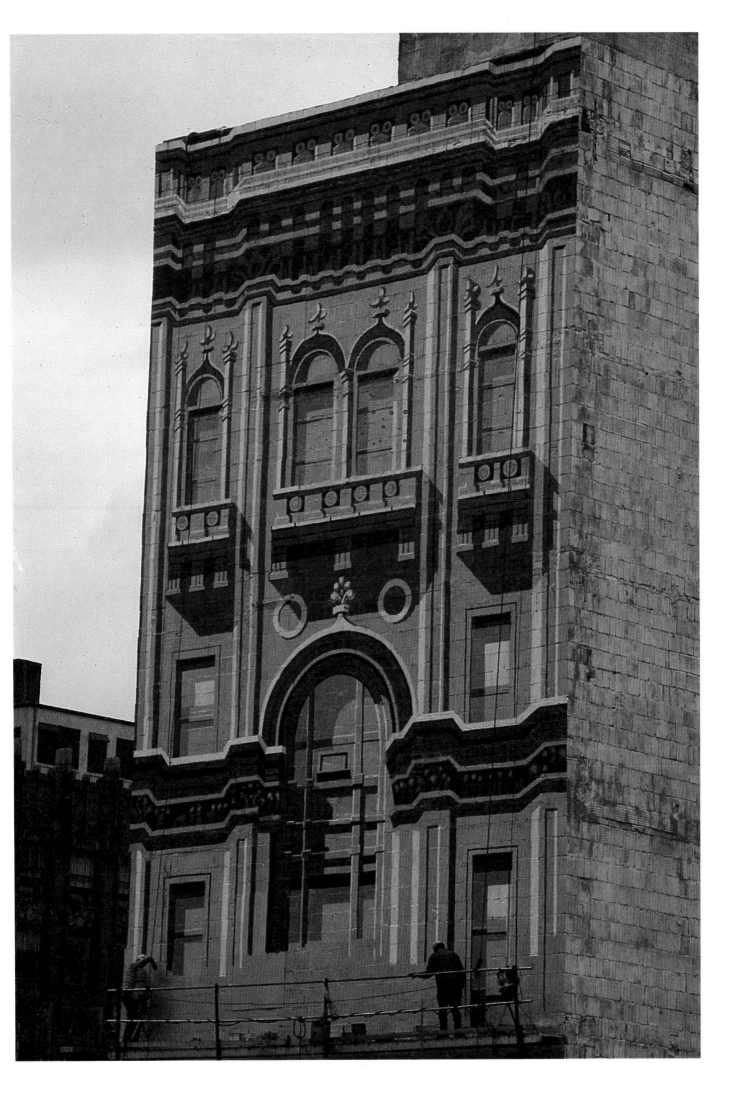

1.

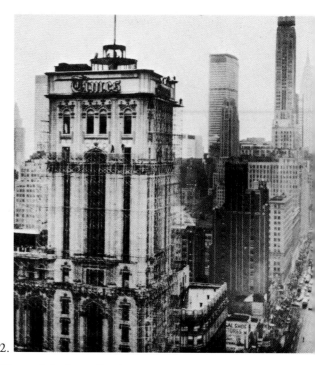

2.

1. Cyrus L.W. Eidlitz and Andrew C. McKenzie's Times Tower as it was originally built in 1903–05. 2. The Times Tower being remodeled in 1966. 3a. The Times Tower as it is today, across Forty-second Street from 3b, the Crossroads Building tower before receiving the Haas *Times Tower* mural. 4. View looking west on Forty-second Street showing the Crossroads Building with its completed *Times Tower* mural.

3.

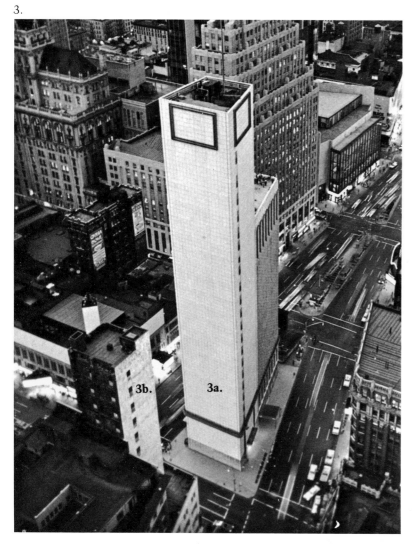

3b. 3a.

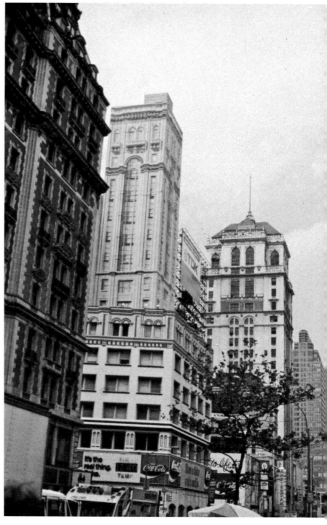

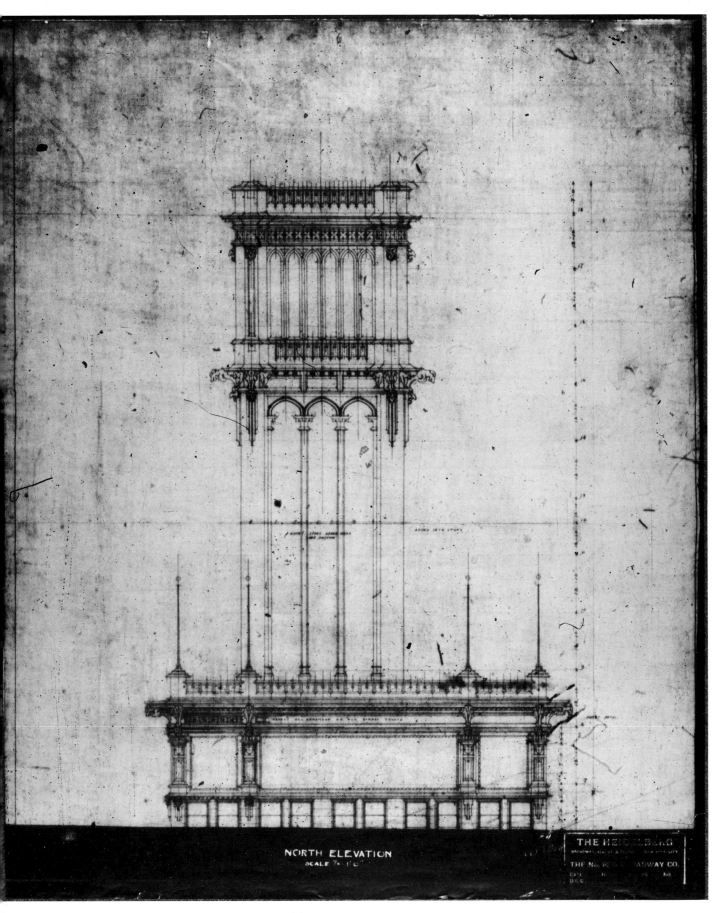

NORTH ELEVATION
SCALE ⅛" 1' 0"

Original blueprint for the tower of the Crossroads Building
(then the Heidelberg), never executed, indicating plans for
gothic terra cotta trim similar to the original Times Tower.

Opposite page: *Homage to the Chicago School*, 1211 North LaSalle Street, Chicago, 1980, 165' high. Commissioned by 1211 North LaSalle Corporation; executed by Evergreen Outdoor Advertising. Left: the apartment house before painting.

least important aspect of the project when completed. I needed to respect its lines and color only. I worked on several drawings and two models in one-sixteenth-inch scale to start with. The Chicago School style seemed best from the start, but other designs included an Italian 1920s eclectic style that had two large niches on the north and south facades. In each of these was a ten-story-high painted Bernini-like obelisk mounted on the back of an elephant. I had always admired the submissions to the Chicago Tribune contest of 1922 and I had studied these over the years. The Italian submissions were among the most outrageous and interesting. Actually a proposal that I had done two years earlier for 700–720 North Michigan Avenue in Chicago, where I cut an arch through the building, was also inspired by one of these entries. Adolf Loos's doric column was always one of my favorite Tribune submissions and I included a shadow of it in the windows on the north facade of LaSalle Street. The top of the south facade included a large ocular window taken from the bank by Louis Sullivan in Grinnell, Iowa, while the lower portion showed a variation of his Golden Arch for the Transportation Building at the 1893 World's Columbian Exposition. The four bas reliefs along the base of the arch, instead of being on transportation, are of four great architects of the Chicago School—Wright, Root, Burnham and Sullivan. The east facade turns

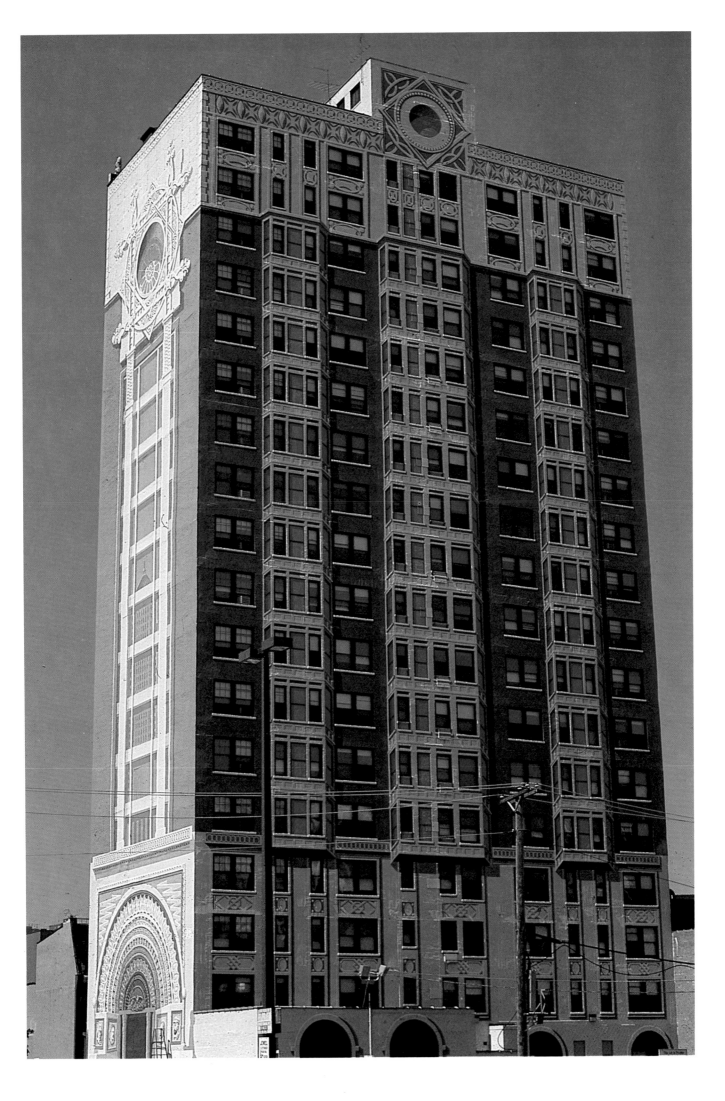

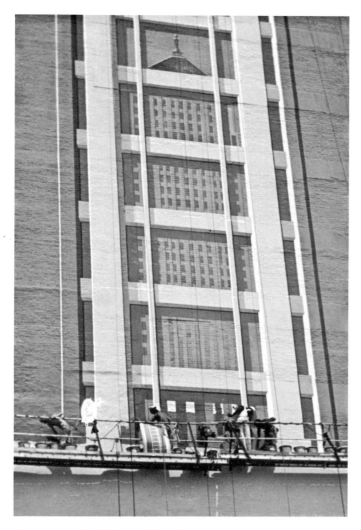

Homage to the Chicago School
(detail showing reflection of Board of Trade Building).

Adolf Loos, Chicago Tribune Tower
Competition proposal, 1922 (unbuilt).

Louis Sullivan, Carrie Eliza Getty Tomb,
Graceland Cemetary, Chicago, 1890 (detail of lunette).

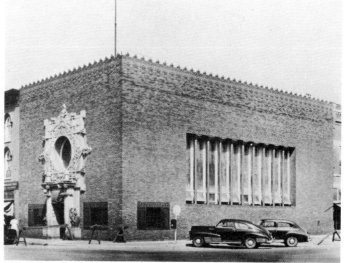

Louis Sullivan, Poweshiek County National Bank,
Grinnell, Iowa, 1914.

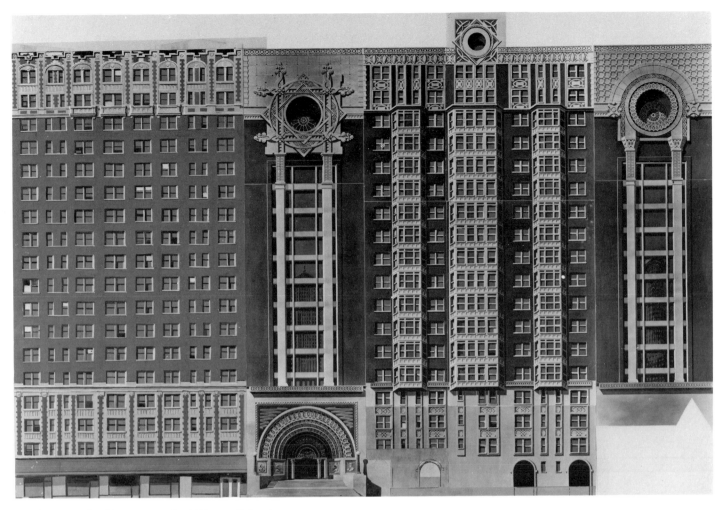

Maquette for *Homage to the Chicago School*
(opened up, showing four elevations), gouache on board, 84 x 136".

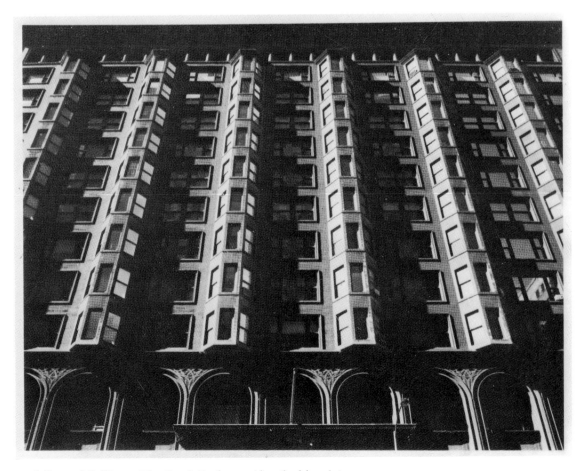

Adler and Sullivan, The Stock Exchange (detail of facade).

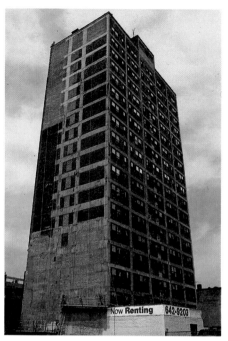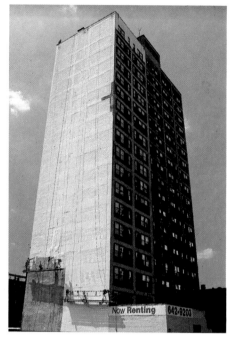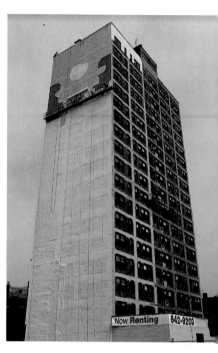

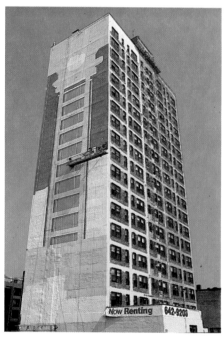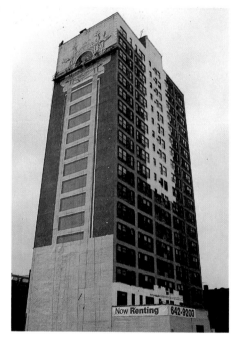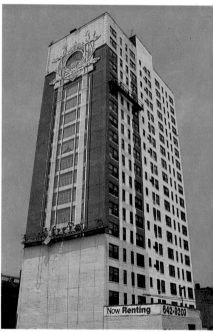

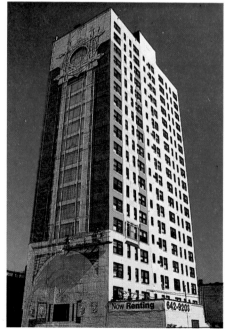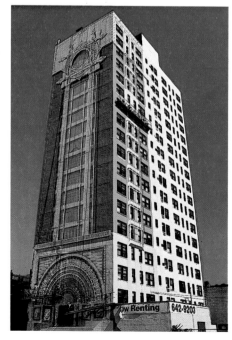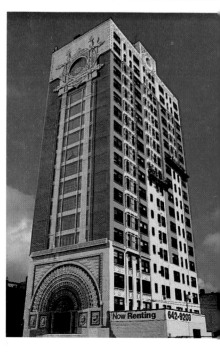

Opposite page:
Homage to the Chicago School,
painting in progress.

Opposite page: *Mineral Spring Concession Stand*, Sheep Meadow, Central Park, New York, 1980. Commissioned by the Public Art Fund and the Central Park Conservancy; executed by John Williams. Above: Mineral Spring House as designed by Calvert Vaux in the late 19th century.

the window program into a series of vertical Chicago bay windows with the elevator tower at the top echoing the ocular windows of the south and north.

This project was my first truly free-standing building which could be read from 360 degrees. I felt more freedom in varying the motifs from one facade to the next. No more than two sides are read at once, and I had fun collaging a variety of ideas together. Architects have often raided the facades of architectural history in order to reconstruct new orders based on grafting fragments with results that are often as interesting as they are bizarre. The north facade is a variation on the south facade. It was taken from the side of the Getty tomb in Graceland Cemetary, north of this site.

Several important differences dramatize the Times Tower and the Chicago LaSalle Street tower and separate them from previous works. By turning the corner they take on a new life. They are no longer two-dimensional, but rather free-standing three-dimensional objects and therefore must be experienced from more than one point of view and one viewing angle. It is interesting that since there is no simple vantage point there is less singular memory of the experience. Several return visits are required to experience the pieces in situ.

The client cooperated in every way to get the best quality execution and materials. We imported the Keim paint mentioned earlier to America for the first time, so the murals should last from fifty to seventy-five years. We used a new and talented young signpainter from New York, Jeff Greene,

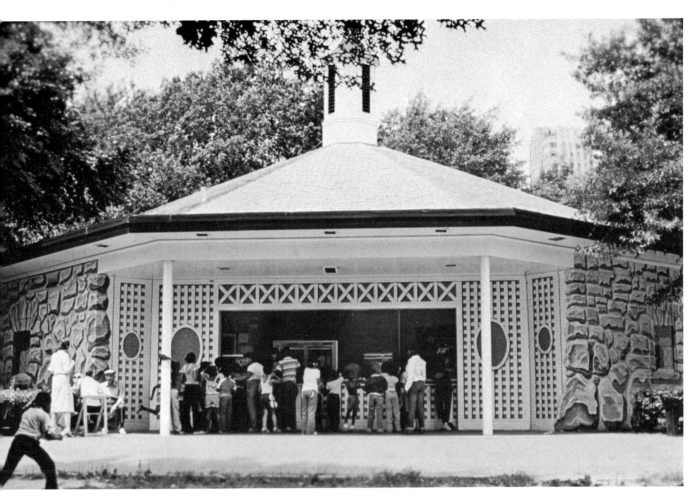

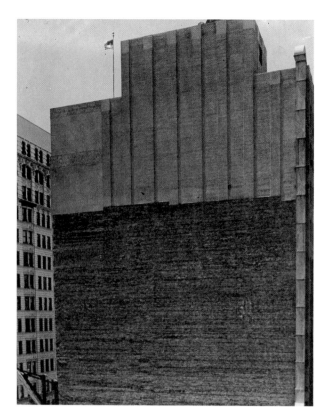

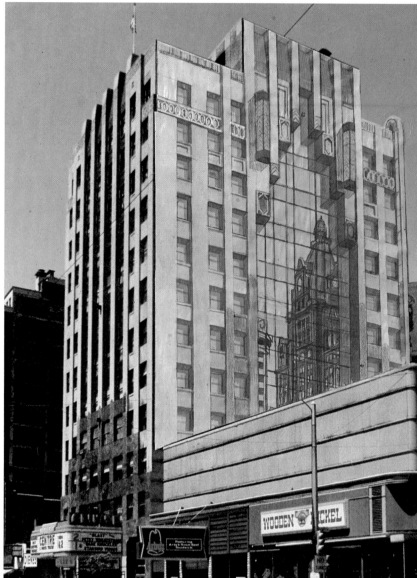

Right: *Study for Centre Theatre Facade*, Wisconsin Avenue, Milwaukee, 1981, gouache on color photograph, 20 x 16". Commissioned by the Milwaukee Downtown Redevelopment Corporation; executed by Evergreen Outdoor Advertising. Above: the facade before painting. Opposite page: maquette for *Centre Theatre Facade*, gouache on board, 68 x 40".

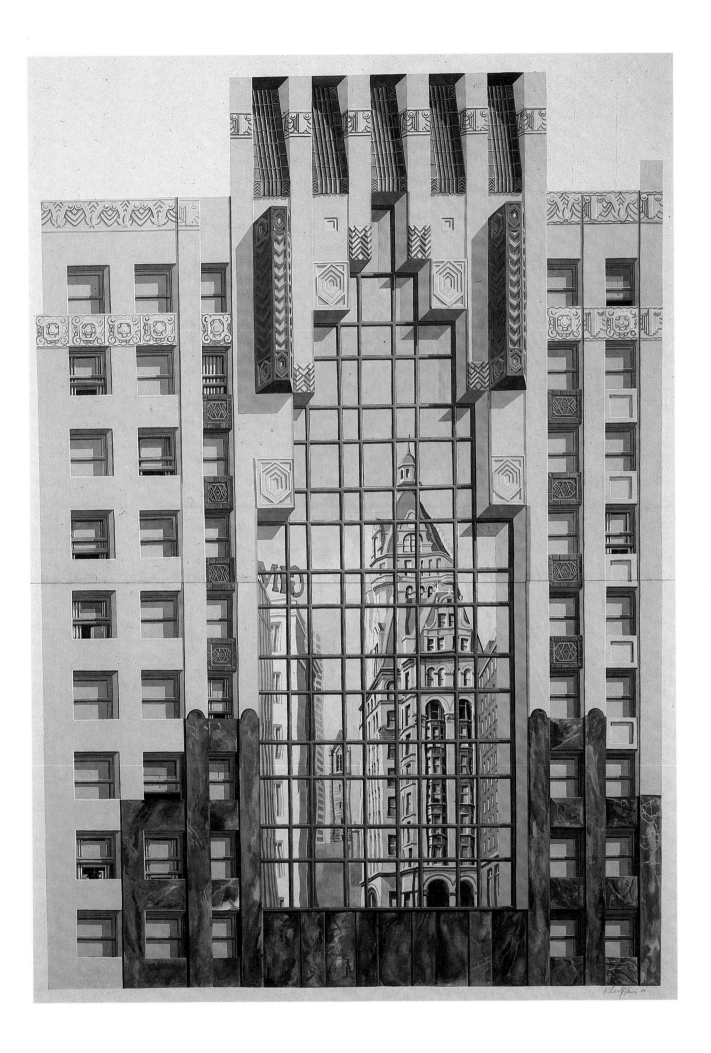

along with five artist assistants.

In 1977 I was asked by the Milwaukee Downtown Redevelopment Project to design a facade for the northeast wall of an Art Deco building between Second and Third streets on Wisconsin Avenue in Milwaukee. The project was not approved until March 1981, so work on it is presently underway. It is a large ziggurat Art Deco "mirror" window that rises up eight floors and reflects the view eastward on Wisconsin Avenue, including the Pabst Building. In 1977, the Pabst Building still existed in the form that I remembered from the early fifties, when its lovely tower was taken off to create a blocky gray top. Since this insensitive modernization was perhaps the first to catch my youthful eye, helping to correct a crime that I remembered from my youth seemed most appropriate. Since then, however, a new and larger crime has occurred; the building has been removed entirely and a contemporary flat-topped forty-story building is planned to take its place. I suggested without result that at least the ghost of the Pabst Building could return to this original site, but I will now have to make do with the reflection on Second Street and one 200-pound carved chunk of the old tower saved for my front yard.

INTERIORS

Right: Paolo Veronese, Fresco decorations at Villa Barbaro, Maser, Italy, c. 1560.

Below: Baldassare Peruzzi, Sala delle Prospettive, Villa Farnesina, Rome, 1509-11.

Opposite page: *Haas Studio Interior*, SoHo, New York, 1974-75, 11 x 17 x 30'.

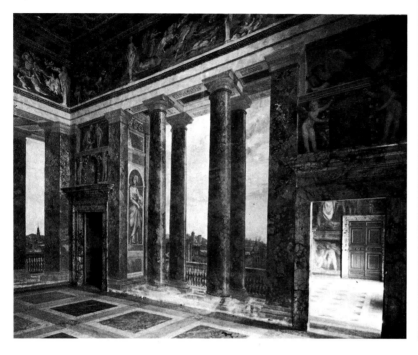

My work on interior architectural decoration began shortly after the Prince Street work was completed. I've always seen the outdoor and indoor murals, though different, as very closely related. Actually, historical precedents for interior architectural illusionism are far greater, more diverse, and refined. Part of the reason for this is that they have been more easily preserved, as far back as buried Pompeiian rooms.

My interior works are extremely different from the exteriors and the intentions and details more. elaborate. My first architecturally painted wall was in my SoHo studio. It began after I had to repair a wall where someone had broken into my loft. I covered a long wall with canvas and painted a balcony bracketed by four green marble pillars and a Palladian ballustrade. But the view from the balcony is of SoHo, exactly what one might see if the bricks were removed. On the opposite wall is a doorway looking through to another doorway and then into a room with a window that shows the World Trade Center (again an exact rendering of what would be seen from that location). The rest of the room is united by a cornice running a foot to eighteen inches below the ceiling, a fake fireplace of canvas, and window details. My primary inspirations were Peruzzi's Sala delle Prospettive in the Villa Farnesina, in Rome, and Veronese's work in the Villa Barbaro by Palladio at Mazer in northern Italy.

Fran and Peter Nelson were the first to commission me to do an interior. Their loft on Canal Street has a long narrow atriumlike space with a skylight some seventeen feet high. I looked for a solution here that would be light, delicate, ornate and colorful. The lean delicacy of Robert Adam and Percier and Fontaine came to my attention at this time. There is a reserve and compression of form in these neoclassical styles as well as a subtle color sense. I carried the ideas begun in my own loft much further in the Nelson space, including every aspect of wall and floor in the design. The work took four weeks, done with a rapidly assembled crew of six artists

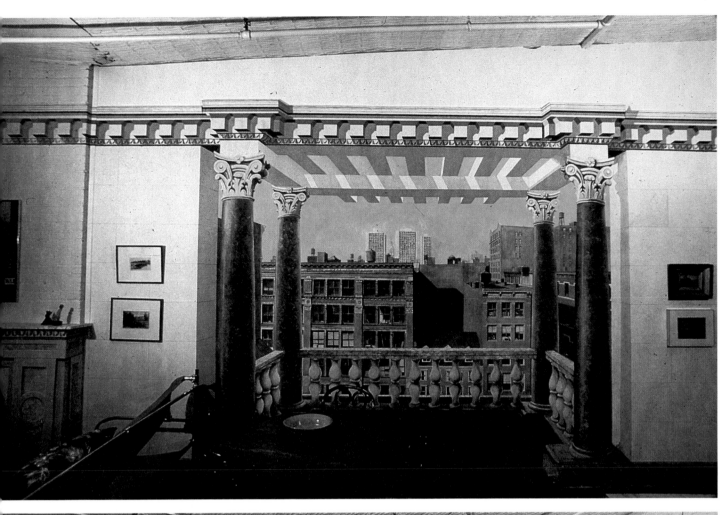

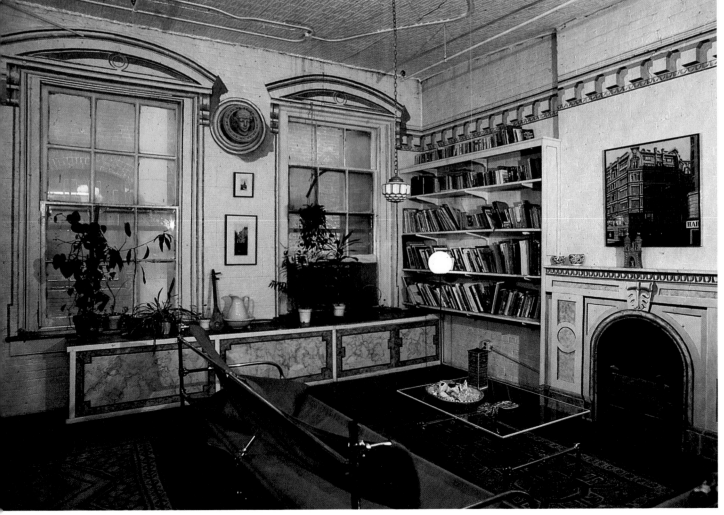

Opposite page: *Nelson Atrium*, Canal Street, New York, 1976,
13 x 15 x 32'. Above: the loft before painting.

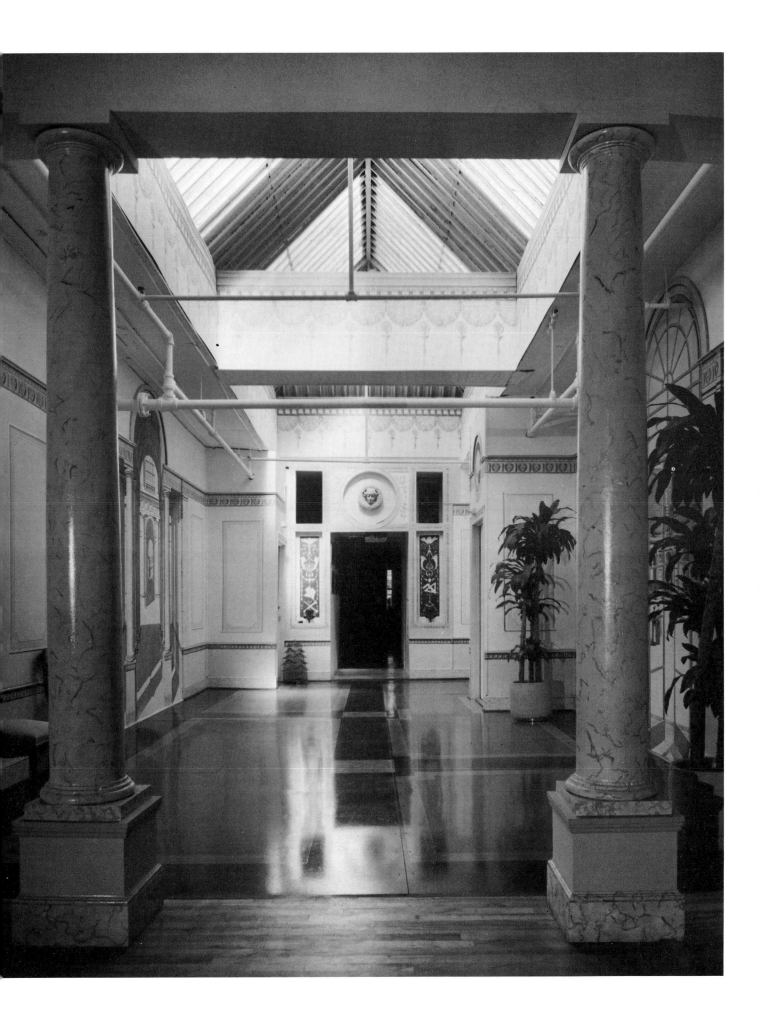

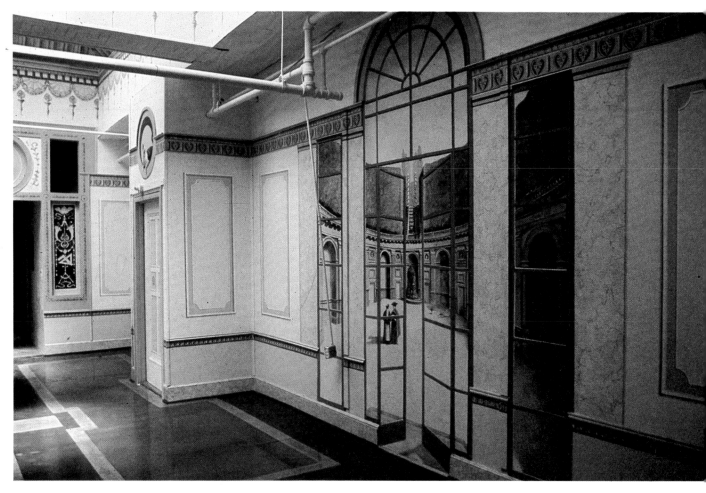

Above and opposite page: *Nelson Atrium* (details).
Below: Aldobrandini Garden, Frascati, Italy.

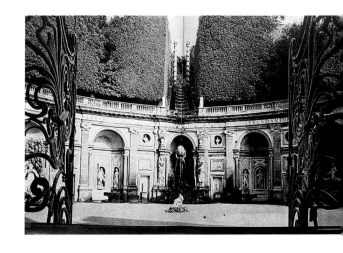

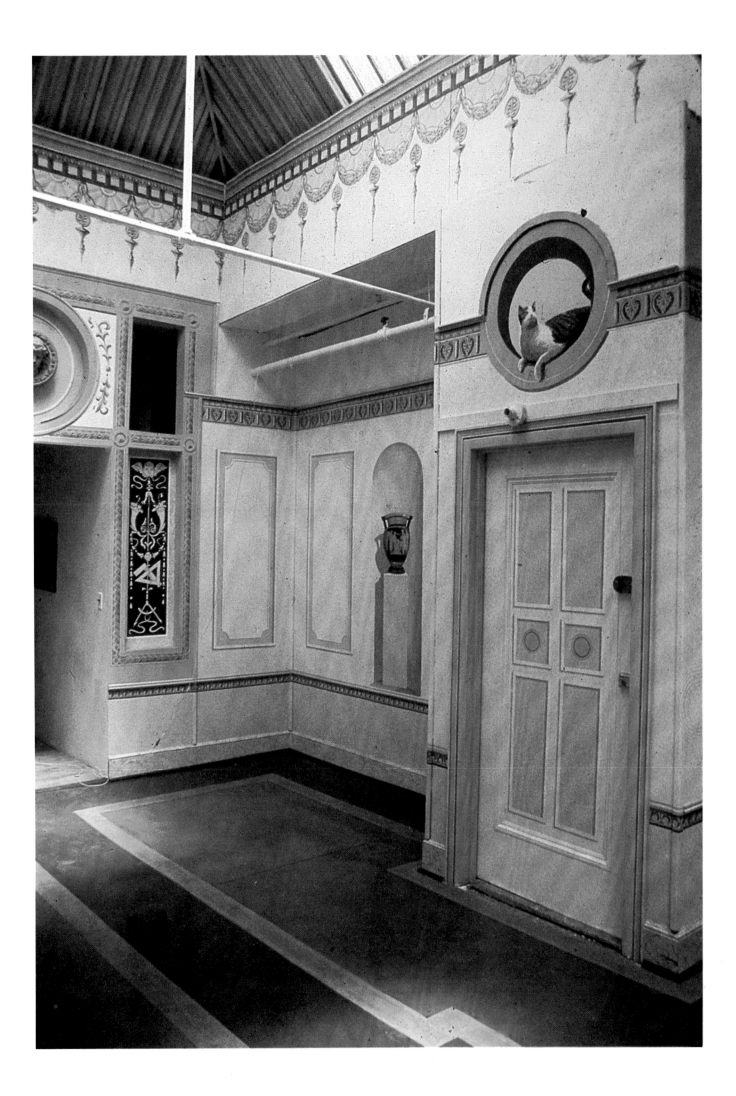

Ca' d'oro, Venice, c. 1424-37.

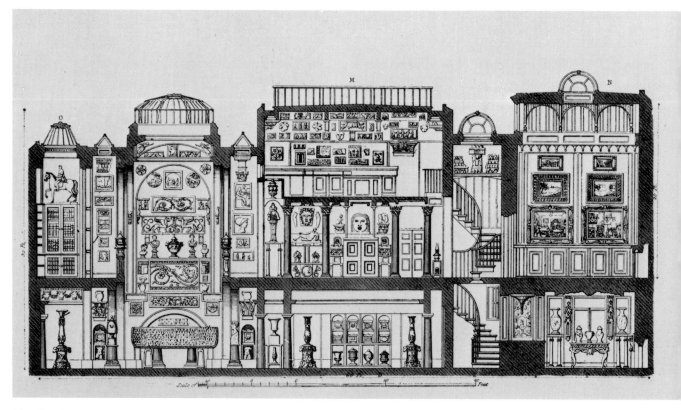

Sir John Soane's Museum, London, 1827 (section).

Opposite page: Preliminary plan for *Venetian Facade* showing plaster replicas of architectural orders on balconies surrounding the mural.

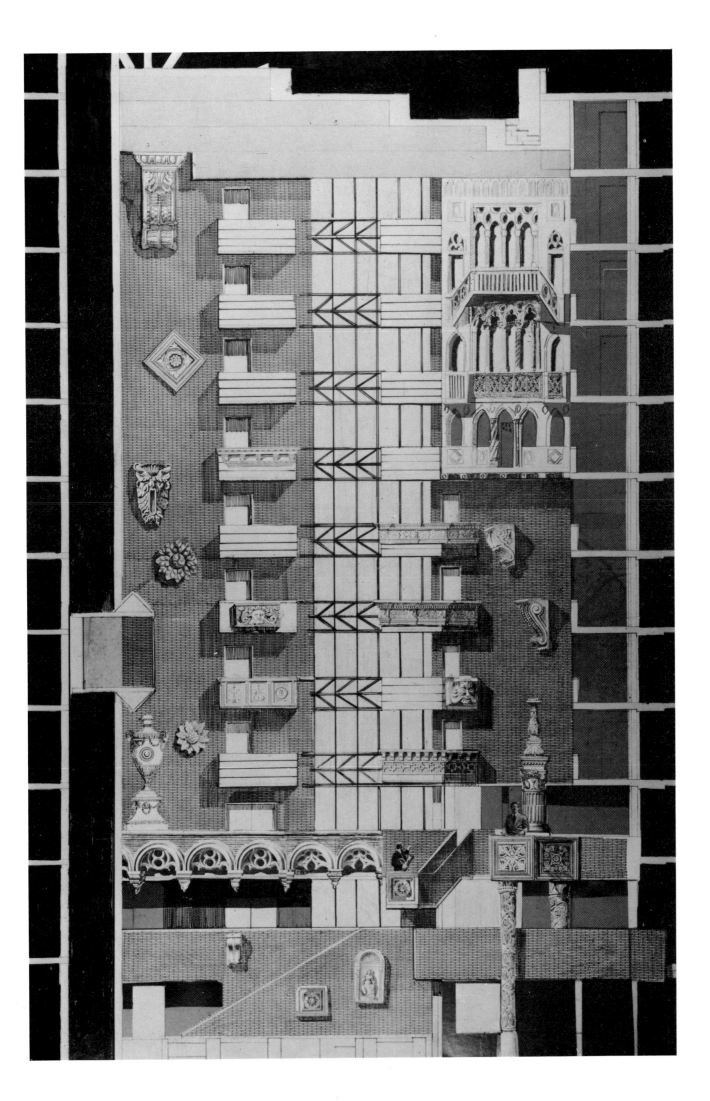

Opposite page: *Venetian Facade*, Hyatt Regency atrium, Cambridge, Massachusetts, 1977, 40 x 20'. Commissioned by Hyatt Regency Corporation and Graham Gund Architects; executed by Seaboard Outdoor Advertising. Above: the wall in the atrium before painting.

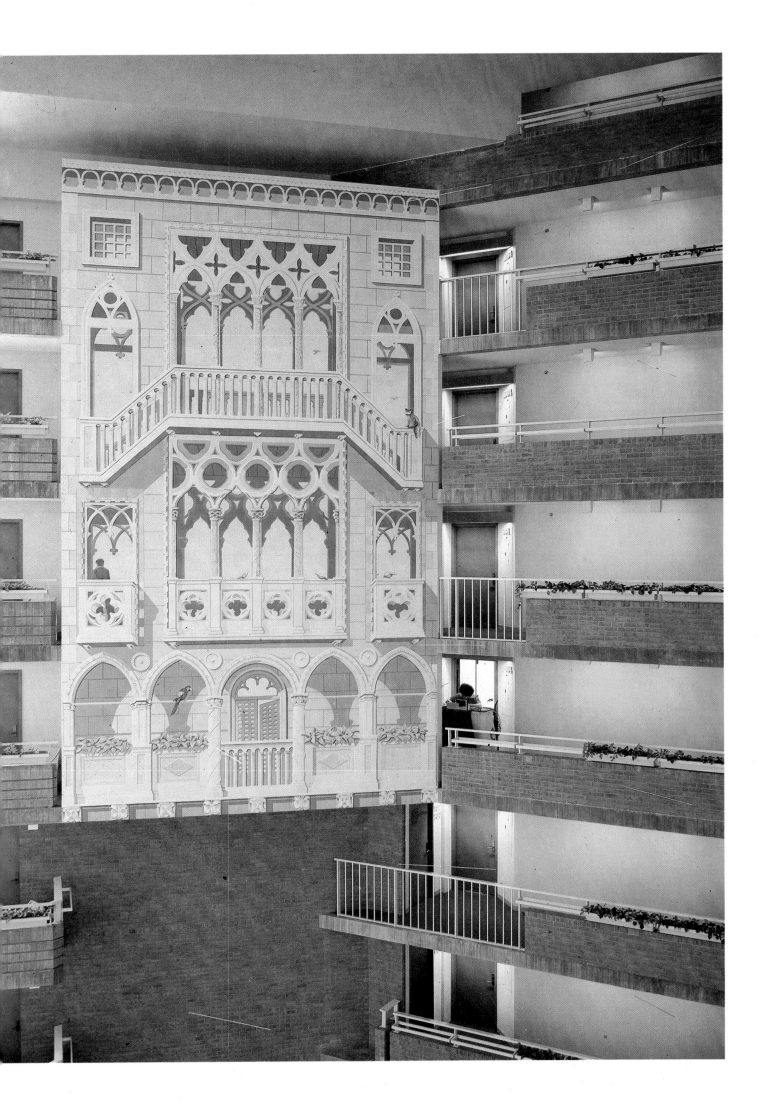

Blackwood-Rosen Dining Room, Alwyn Court, New York, 1977, 10 x 12'.

working in summer heat. We improvised silk screens for repeated patterns and screened directly on the walls, adding detailed colors later. The two major views were the Aldobrandini Garden at Frascati on the east wall and the Farnese Courtyard entrance on the west.

My enthusiasm for Robert Adam as well as Empire did not seem incompatible with each other or with earlier Italian Renaissance details. I did not feel the need to reconstruct a period style in faithful authenticity as I was personally not involved with restoration. My desire then and now has been toward reinvention, or simply invention around historical ideas that can cohabit in a space.

One of the great difficulties in working in someone's home is establishing and preserving the sensitive client-artist relationship. This is probably why I have completed so few interior projects to date in spite of the fact that they have been well publicized and appreciated. There must be a combination of sympathy, diplomacy, trust and openness to allow an interior piece to work. Many peo-

Above and left: details of terra cotta ornament on the exterior of Alwyn Court.

Eight Manhattan Views, Center for Continuing Education,
New York University, 11 West Forty-second street, New
York, 1979. Commissioned by Voorsanger and Mills
Architects and New York University; executed by Charles
and Junja Parker. Above: Washington Square Arch; opposite
page: the World Trade Center.

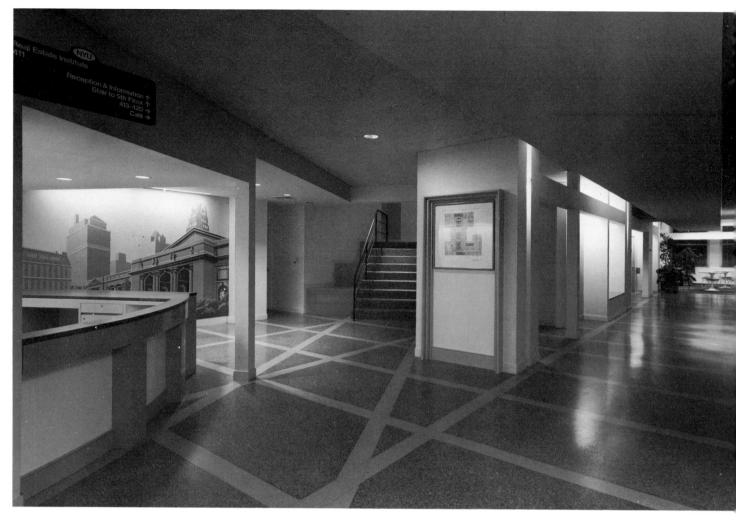

Eight Manhattan Views (detail, New York Public Library).

ple seem to desire the embellishment, but few really wish to see it through, perhaps because it requires a considerable adjustment in their spatial lives.

Shortly after completing the Nelson interior, I was offered another project that falls between the exterior and interior pieces. This was the Venetian facade I completed in the atrium of the Hyatt Regency Hotel in Cambridge, Massachusetts. The architect was Graham Gund, who happens to be a major contemporary art collector as well. There was a twenty-by-forty-foot protrusion from the seventh to the eleventh floors that was not in the original plan but had been added to enlarge the luxury suites.

I had a very difficult time finding a solution that could function separately from the rest of the atrium and still lock in. In one of my early designs I showed a cross-section that attached plaster fragments of classical, Renaissance and gothic ornaments to the brick walls and balconies throughout the entire atrium space. The inspiration was Sir John Soane's atrium in his London townhouse.

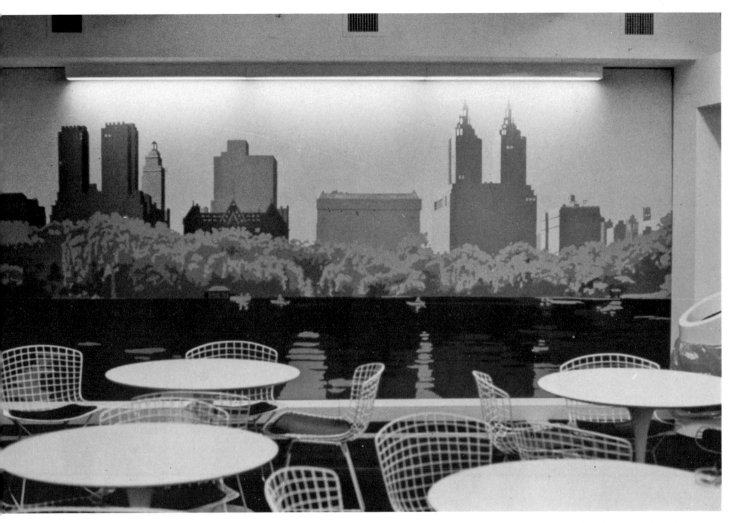

Eight Manhattan Views (detail, Central Park).

Soane's gallery at the rear of his house is a cluttered, yet grand collection of antique remnants that overwhelms the space. I thought that a similar sense of clutter would be wonderful on the balconies of the Hyatt atrium. The actual protrusion was treated as the Ca d'oro in Venice surrounded by other plaster elements of a similar period. I am still very fond of this concept, but, needless to say, neither the architect nor the Hyatt people were ready for this transformation—especially since the hotel was already open for business. Could the Venetian facade, which I liked, stand by itself in this space? After some collage work, I decided that it could and then worked to scale the balconies and the color to the actual space. The piece was completed in a week's time during September of 1977, while customers ate breakfast and lunch—some seventy feet below.

In December of that year Nancy Rosen and Michael Blackwood approached me to consider painting the wall of their dining room in the Alwyn Court, a wonderful early twentieth-century New York apartment house with a Francis the First terra cotta exterior. The interiors, however, had been

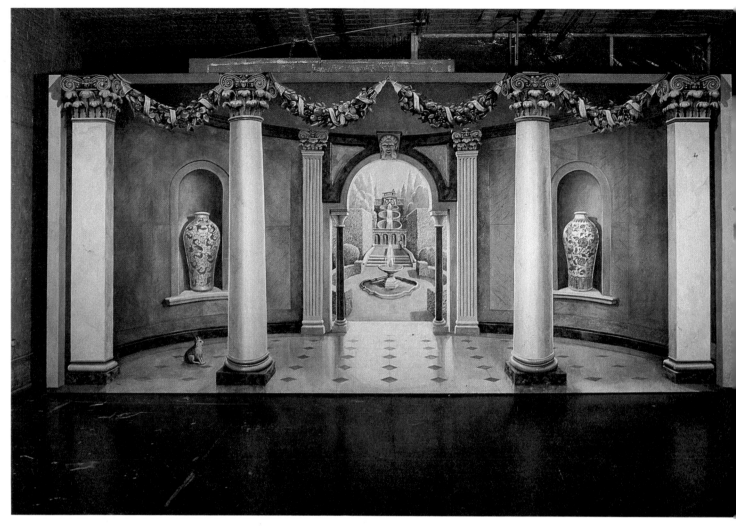

Garden Entrance Alcove, Wentworth Melbourne Hotel,
Melbourne, Australia, 1980, 16 x 20'. Commissioned by
Wentworth Melbourne Hotel and I.M. Pei and Partners.

stripped and remodeled during the Depression. The
wall was small, and in a space that was white and
contemporary in feeling. I had a good knowledge of
the building since I had done an etching of the
exterior in 1972. I chose to use elements of the
exterior decor, but in smaller scale, and to do the
entire wall in light grisaille so as not to protrude
into the room too greatly. This was the first project
where I drew a full-scale paper cartoon and pounced
it onto the wall with charcoal in the manner of
Renaissance painters. I have since then been involved in a proposal scheme that includes painting the
twelve-story light well inside the building as a
courtyard in a style reminiscent of the exterior.
This project should be completed in early 1982.

A mural project involving the architects Voorsanger and Mills was the first successful collaboration amongst the client, architect and myself on a
new project. Bart Voorsanger and Ed Mills formed
an architectural firm after having had much experience working with major firms such as I.M. Pei
and Richard Meier. The floor plan for the fourth
floor of New York University's building at 11 West
Forty-second Street was laid out by the architects to
simulate the map of central Manhattan, and thus
the halls running north and south became Fifth and

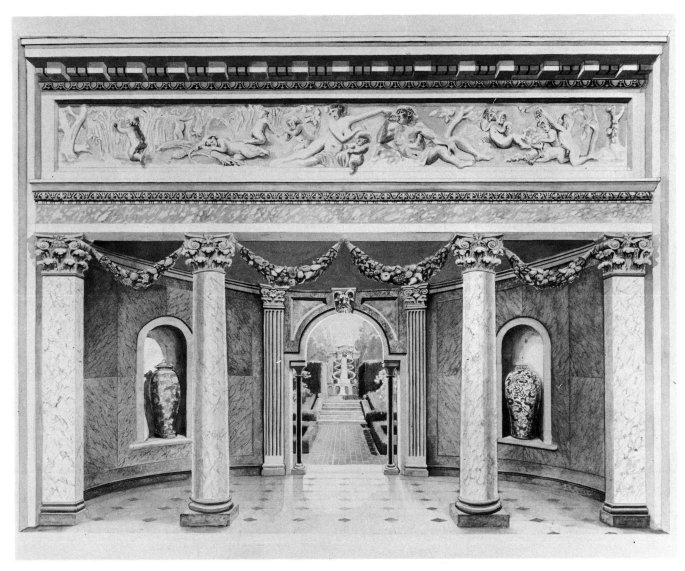

Study for Garden Entrance Alcove, 1980, watercolor on ragboard, 37 1/8 x 44 3/4".

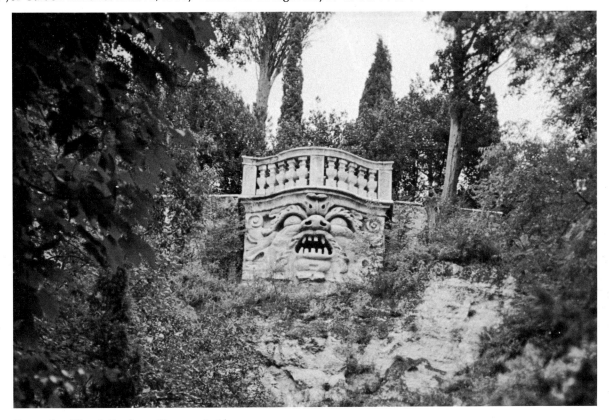

Fountain, Giusti Gardens, Verona, Italy.

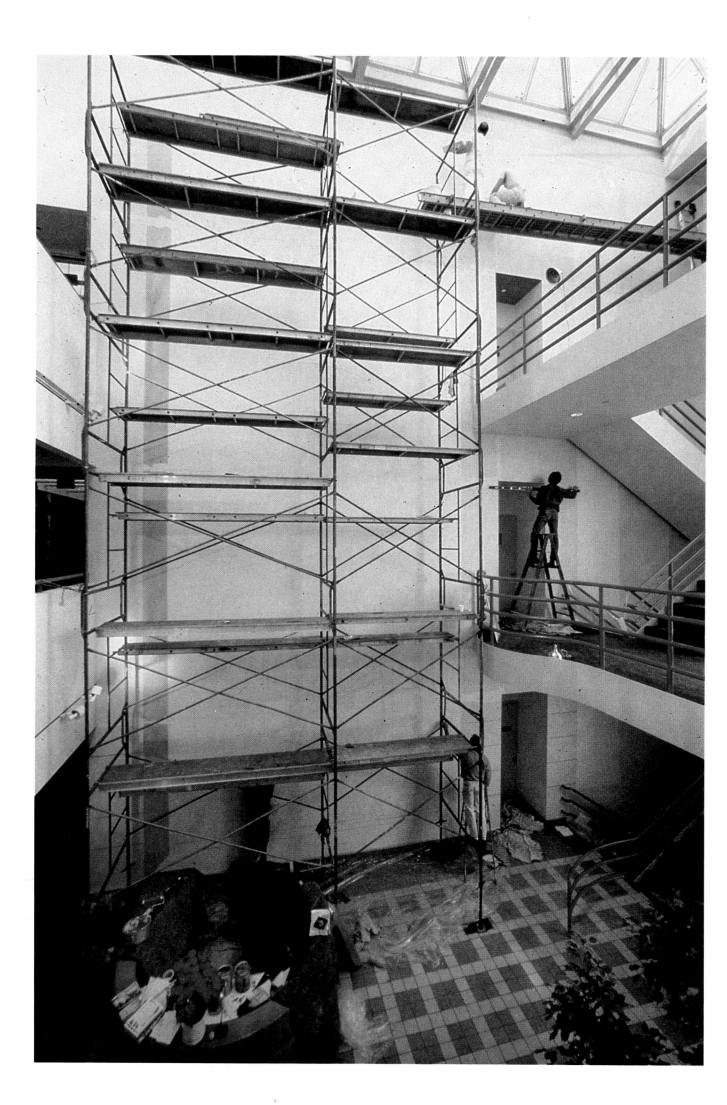

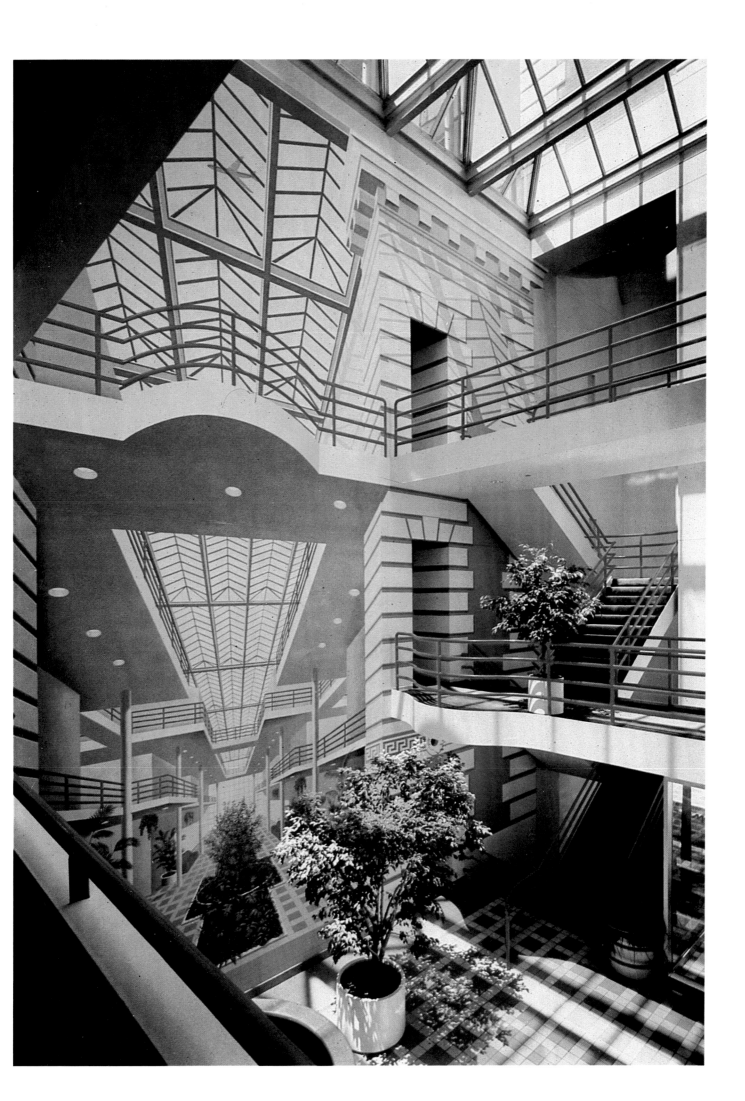

Sixth avenues and the cross aisles became Eighth, Thirty-fourth, Forty-second, and Fifty-ninth streets, respectively. The lunch room on the north end was Central Park and the board room on the south Washington Square. The reception area was Times Square and the executive offices Greenwich Village. It works as subtle interchange with an otherwise very dull hallway system. The terrazzo floor also describes city blocks and the angled Broadway. The budget was low and I had to limit my murals to eight crucial sites. I photographed over twenty places in New York before arriving at my final choices for Central Park or the two views through the arches of Washington Square, for instance. I would like to have seen more sites used and also a use of light silhouettes on walls of the long halls. This was all beyond budget. The works were executed by Charles and Junja Parker, both of whom did an excellent job enlarging my two inch to a foot gouache drawings.

Shortly after completing this project I was approached by Robert Lym of I.M. Pei to complete a wall sixteen by twenty feet on the end of a restaurant atop a hotel in Melbourne, Australia, designed by the firm. There was little latitude for discussion about construction or color accommodations, so that the piece had to be thought of as wall-to-wall self-contained painting rather than as an environmental installation. I have found, after several attempts to make this kind of situation work, that it really seldom does to my satisfaction. I prefer a more fluid exchange between artist and architect truly to make the pieces succeed. All elements— color, shape, lighting and edge—must be considered. I did, however, feel that the scale and quality of the sixteen-by-twenty-foot neo-Renaissance niche that was painted in our studio was of a quality and finish not previously achieved. I await installation to see how the scheme works in the context of room.

Another project in which I was able to collaborate more fully with architects was an atrium for Meredith Communications in Des Moines, designed by John Locke of Charles Herbert and Associates. Here my work continues the high-tech feeling of the new balconies, floor and ceiling and links them to the older American Renaissance facade and tower of the original building. My forty-by-twenty-foot painted "break" in the wall exposes a vista of continuing halls and balconies and thus expands an otherwise too-enclosed atrium courtyard to nearly endless scale.

Two museum projects that combine several effects of interiors were done between 1979 and 1981. I had done several gallery installations that led up to these projects, where I silkscreened

Meredith Communications headquarters, Des Moines, Iowa, exterior.

Previous pages: *Atrium*, Meredith Communications headquarters, Des Moines, Iowa, 1980, 40 x 70'. Commissioned by Meredith Communications and Charles Herbert and Associates Architects; executed by Evergreen Outdoor Advertising.

Detail of *Atrium* showing rusticated stonework that echoes exterior.

Walker Facade Scrim, 1979, for the exhibition "Eight Artists: The Elusive Image" at the Walker Art Center, Minneapolis, Minnesota. Scrim: 14 x 28'; backdrop: 14 x 36'. Opposite page: detail of *Walker Facade Scrim* showing exterior, grand staircase, and portrait of the founder, T.B. Walker, on stairs.

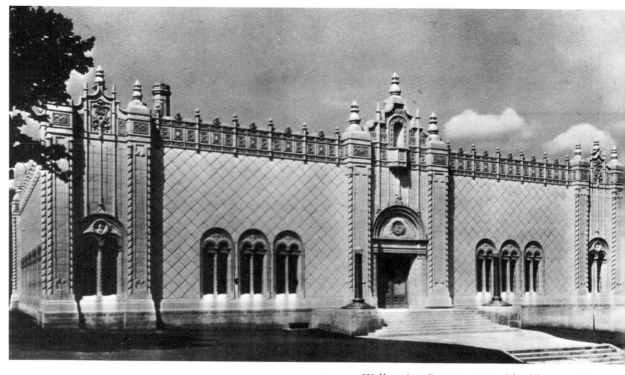

Walker Art Center, original building, 1927.

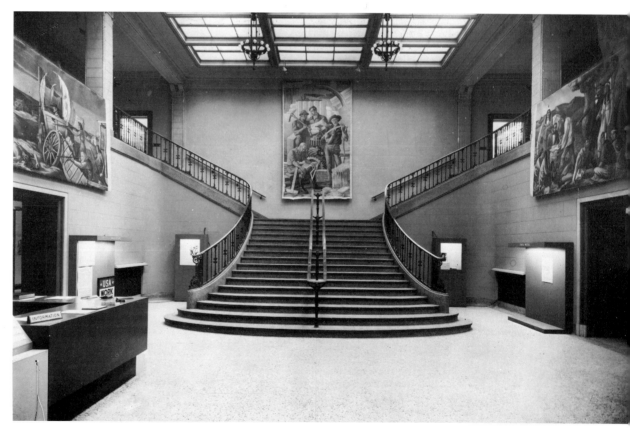

Walker Art Center grand staircase, 1927.

Walker Art Center as remodelled, 1944.

Present Walker Art Center building designed by Edward Larrabee Barnes, completed 1971.

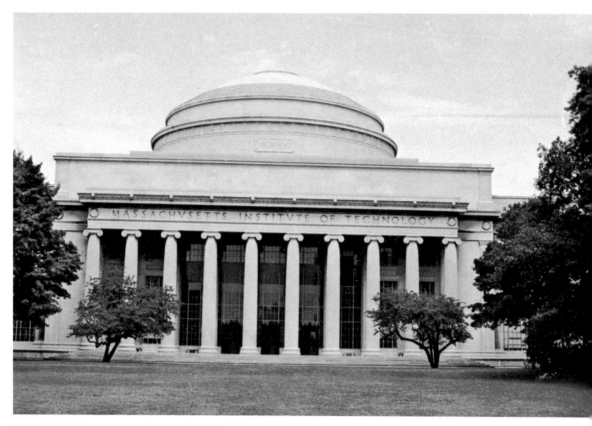

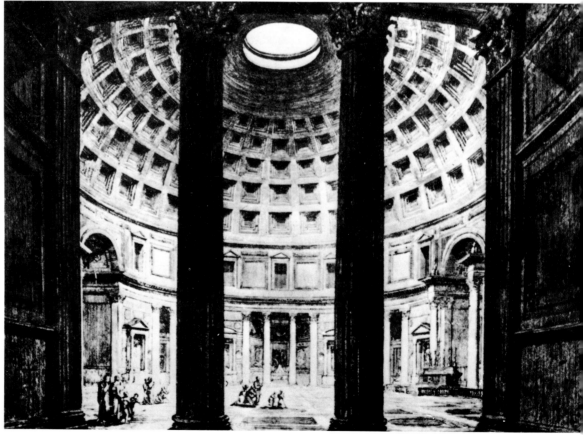

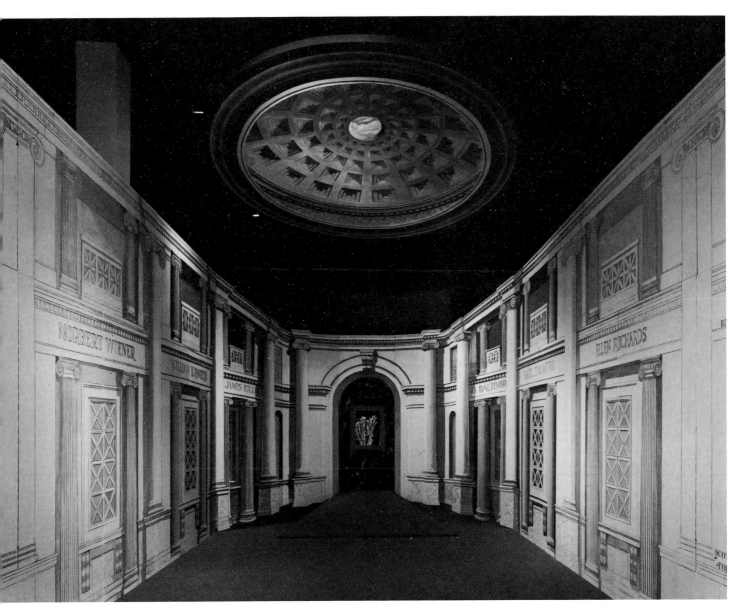

Pantheon d'honneur, 1981, for the exhibition "Rooms by Three Artists" at the Massachusetts Institute of Technology, Cambridge, 1981, 12 x 12 x 30'.

Opposite page, above: MacLauring Building, Massachusetts Institute of Technology.

Opposite page, below: the Pantheon, Rome, 2nd century A.D.

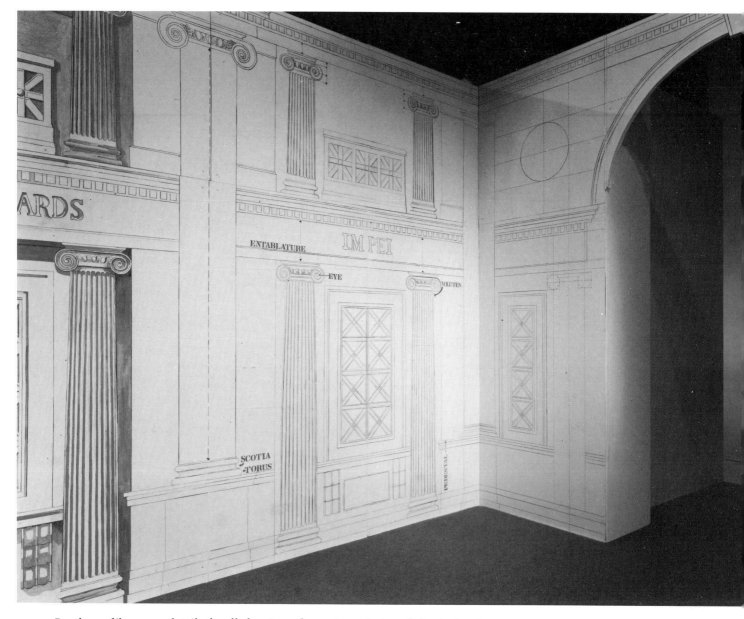

Pantheon d'honneur, detail of wall showing schematic rendering of classical orders.

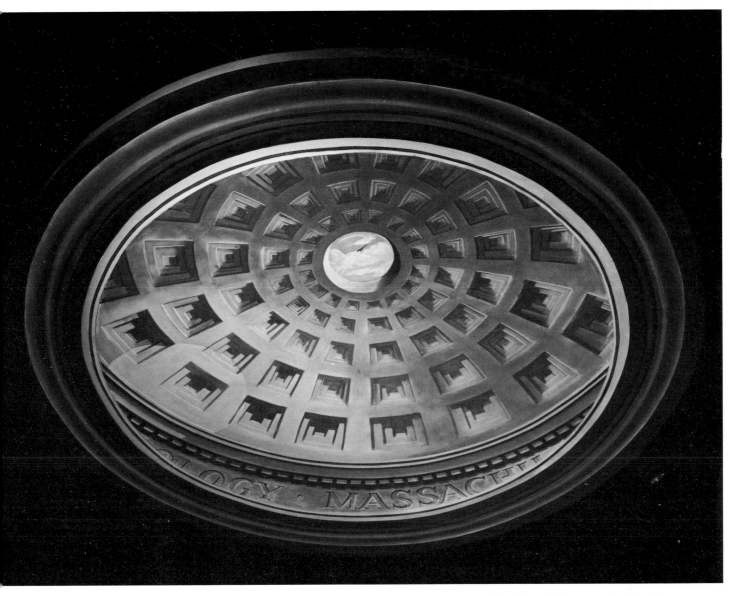

Pantheon d' honneur, detail of dome.

decorative motifs onto Contact paper and installed
friezes, chair rails, marble trim and plaster molds
around rooms to embellish gallery or museum
exhibitions of my work. I called these "portable
mutable" interiors. The idea was that we can
change interiors rapidly and painlessly with chang-
ing moods. It suggested solutions for the mobile
apartment dweller who inhabits bland spaces but
wishes to suggest a variety of periodlike embel-
lishments. The collagelike interior also echoes·the
multi-faceted taste of collecting today, where
several periods may overlap in one apartment.

The first museum project was a piece for the
"Elusive Image" show at the Walker Art Center in
October 1979, organized by Lisa Lyons. Here a four-
teen-by-twenty-eight-foot scrim was placed in front
of a fourteen-by-thirty-six-foot indented backdrop.
The scrim depicted the facade of the original
Walker building, circa 1927, at about one-third
scale, while the backdrop showed the old main

entry hall of the same period. This was approximately one-half scale. The effect was of seeing an apparition of the old space through the vaporous scrim of the old building. The scale was very uncertain and this surprise along with the subtle sense of focus was what made the piece work for me.

In a piece for an exhibition of three environments by three artists at the Massachusetts Institute of Technology, organized by Susan Sidlauskas, I chose to do a fourteen-by-thirty-foot neoclassical hall in the style of the old MIT campus. There was a flat painted dome over the center, and along the walls were names of important MIT personalities. The work progresses from light schematic outlines at one end of the hall to full illusion at the other. It was entirely done in grisaille on Gatorfoam, which offers a beautiful surface to work on.

I have constantly sought ways of working on indoor spaces that allow the work to be linked to the anonymous and mundane surfaces of most twentieth-century architecture. I also want to find means of combining contemporary forms and hardware with historic allusions, where the merging of styles does not clash, and finally to find means of executing the more refined detail required by indoor painting. Each work is something of an experiment in finding the means of making interior spaces work. The MIT project offered more potential solutions than I have found in some time. It was lean and schematic. It moved from subtle background to full-bodied illusion. It gave us full theatricality plus decoration as background art, and the shifts were very soft and smooth.

PROPOSALS

Throughout the period when I worked on projects that were completed I also proposed a great many that either never happened or were conceived as hypothetical in the first place. I briefly mentioned my shadow proposals earlier. The placing of the full-scale shadows of the Empire State and Chrysler buildings on the north faces of the twin towers of the World Trade Center was for me a way of playing with scale and measurement in the city while retaining an aspect of subtlety and plausibility in the work. There was a sense of displacement in both space and time, since the earlier and later towers remain within view of each other but are three to four miles apart. They also represent different phases in the history of skyscraper construction.

My ideas about shadow soon evolved toward placing the shadow of a major tower that had been removed on an appropriate wall near the site. Such sites exist everywhere in New York and many other cities as well. The three subjects I chose first were St. John's Church, on Varick Street below Canal, which stood for over 100 years as the chief landmark of that section of the city; the tower of Madison Square Garden (by McKim, Mead & White, long-standing heroes of mine) with St. Gaudens's *Diana* at the top, which stood on the corner of Twenty-sixth Street and Madison Avenue (my shadow was for a building near Twenty-fourth

and Park); and the Singer Building, which stood at 149 Broadway for almost sixty years and for about five years was the world's tallest.

I also drew proposals for returning full-scale facades of certain buildings to their sites. The best example of this was to put back Frank Furness's First Provident Bank of Philadelphia on the wall adjacent to where it stood at Fourth and Chestnut streets. In 1975 I did a series of hypothetical skyscraper drawings based on such Italian buildings as Santa Maria delle Grazie in Milan and Santa Maria della Consolazione in Todi. I had long been familiar with the Chicago Tribune Tower competition and it has served as an inspiration for the permutations possible in a similar program using historical allusions. Two other sources were Sir John Soane's drawings of churches in different architectural styles and those for Schinkel's Friedrich-Werdersche Church in Berlin.

When I started to make proposals for Chicago projects the Tribune competition was on my mind, especially when I did the cutaway proposal for 700-720 North Michigan Avenue. There the Palladian top suggested the form of the penthouse that I added, but the cutaway related to proposals for the Tribune Tower in 1922. The large cold storage building at Wolf's Point on the Chicago River, a dramatic and historic Chicago site, was brought to my attention by Stuart Cohen in 1976. I wanted to

*oposal: To Paint the Shadows of the Empire State and
*hrysler Buildings on the North Sides of the World Trade
wers, 1975, pencil on photograph, 16 x 12".

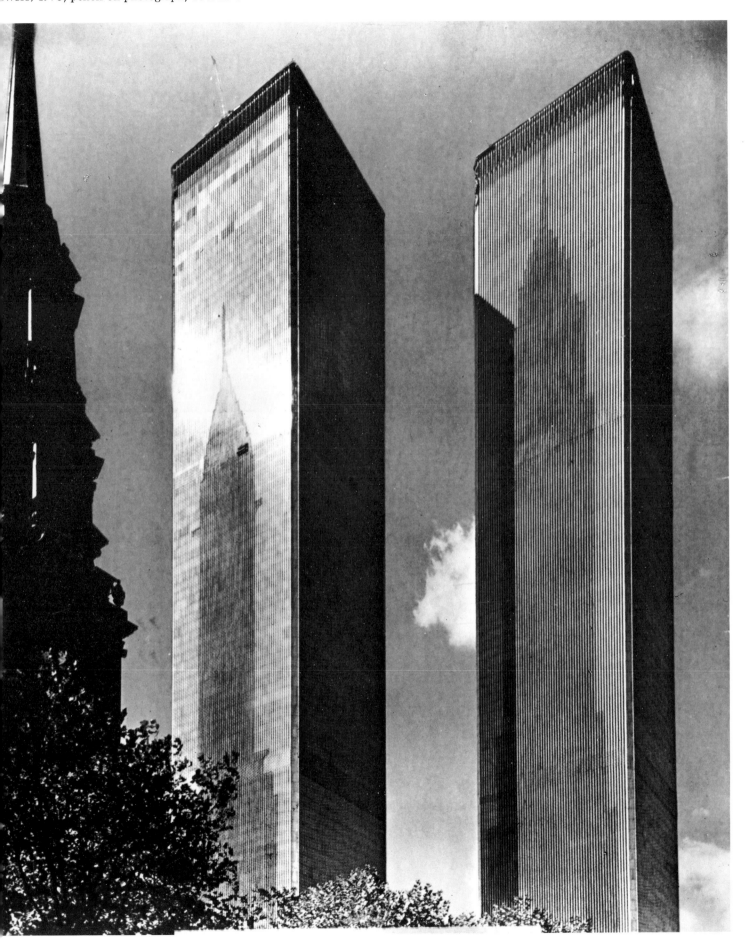

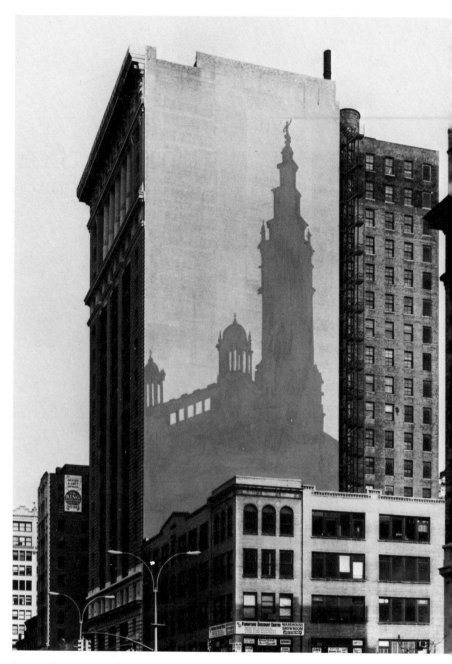

Proposal: To Paint the Shadow of Madison Square Garden,
1975, gouache on photograph, 20 x 16".

Madison Square Garden, Twenty-sixth Street and Madison
Avenue, built 1891, destroyed 1926.

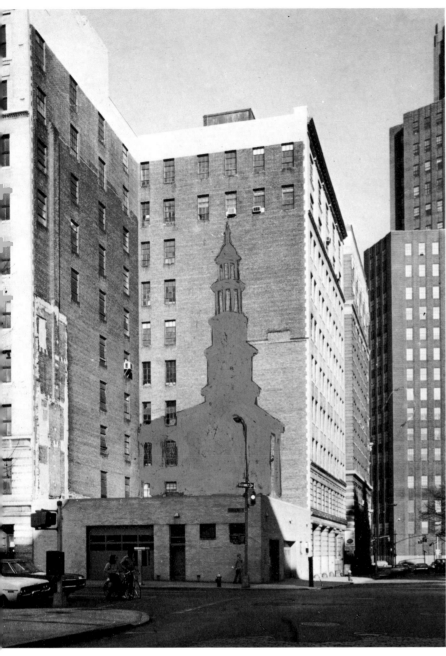

Proposal: To Paint the Shadow of St. John's Chapel,
1975, gouache on photograph, 20 x 16".

St. John's Chapel, Varick and Beach streets, New York,
built 1813, destroyed 1919.

The Singer Building, 149 Broadway, New York; built 1906, destroyed 1966.

Singer Building, New York.

Proposal: To Paint the Shadow of the Singer Building,
1975, gouache on photograph, 20 x 16".

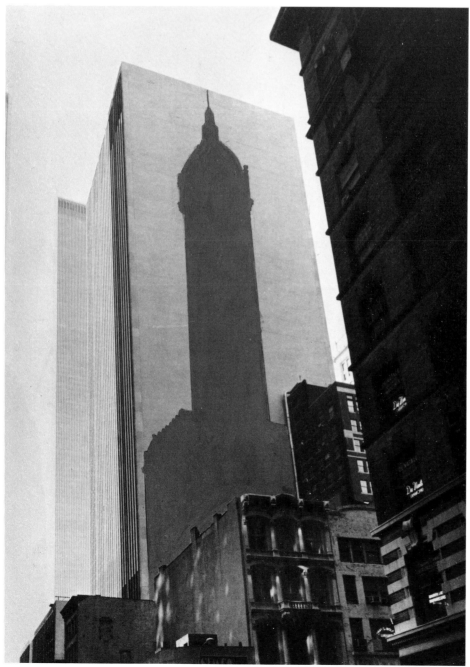

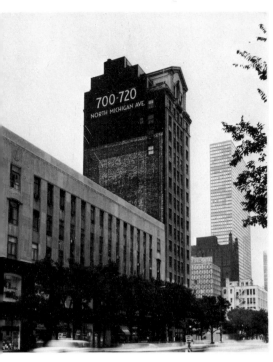

700-720 North Michigan Avenue Proposal,
1977, gouache on photographs.

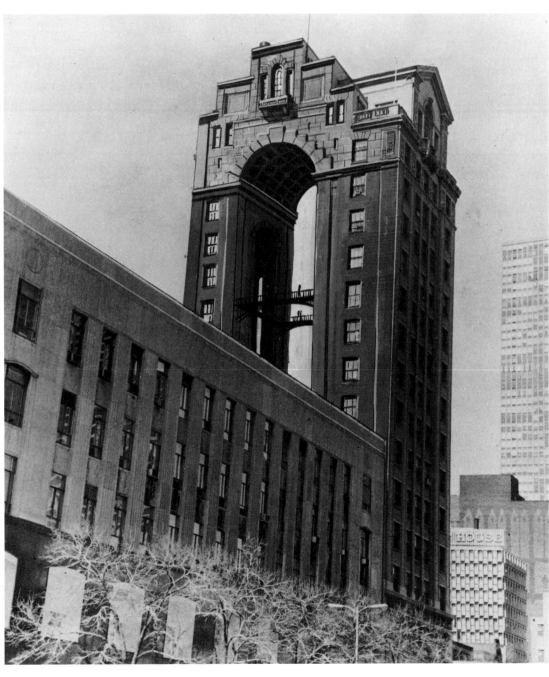

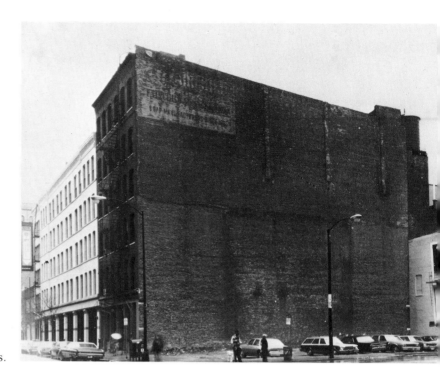

Chicago Arcade Proposal, 1977, gouache on photographs.

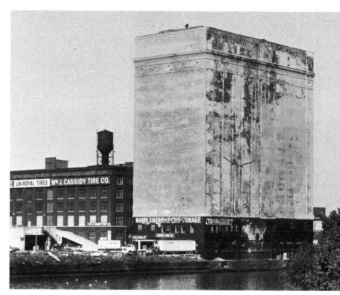

Howard Street and Broadway Proposal,
1977, gouache on photographs.

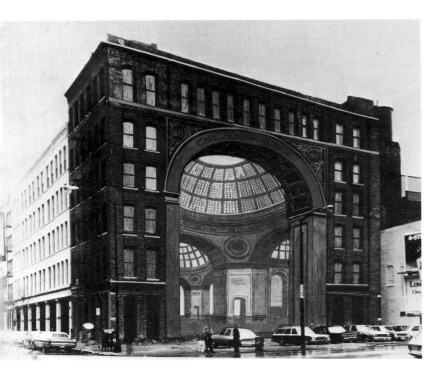

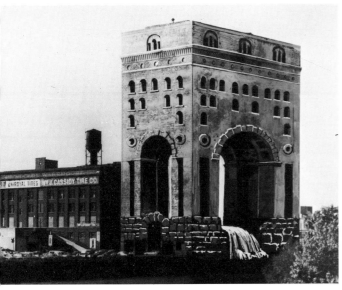

Chicago Warehouse Proposal, 1977, gouache on photographs.

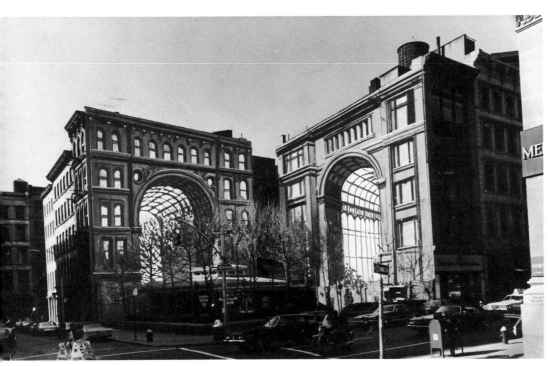

Frank Furness, First Provident Bank, Philadelphia;
built 1885, destroyed 1952.

give it a scale that could compete with such adjacent giants as the Merchandise Mart and to enhance its connection to the water. That is why I chose a sort of Boullée-like cutaway arch with a rusticated bottom. I also did a proposal for Hubbard Street that looked into a tremendous Chicago-style arcade on which were inscribed appropriate Chicago heroes' names.

At about the same time I did proposal for a project for the Central Medical Hospital in Pittsburgh, a fifteen-story contemporary structure that stood on a hill hovering over the downtown area. The south facade was a block 40 by 110 feet. I designed a large cutaway related to the Belvedere cut in the Vatican by Bramante and certain cutaways found in Nicholas Hawksmoor's buildings in London. The interior was to be of soft yellowish rusticated stone. The project was, however, rejected by the hospital board for reasons which were never explained.

I have also proposed ideas in drawing form since 1975 for putting lightweight decorative tops back on buildings. This idea has, in part at least, become more and more a reality, as architects' concern for anti-flatness grows in high-rise design. Suggested drawings included a Slinky-like aviary for eagles connecting the World Trade Center towers. Also, lightweight fantasy tops could be dropped by helicopter on the Pan Am Building in New York, the Shell Building in Houston, and the Exxon Building in Chicago, to mention but a few. Other fantasy drawings I have made include sketches of what upper Park Avenue or Sixth Avenue might look like in the late years of post-modernist revivalism. I am, of course, amused by their (circumstantial) relationship to the imaginary views of a similar nature of future cities by Hugh Ferris and Raymond Hood.

I mentioned the indoor design for Michael Blackwood and Nancy Rosen at Alwyn Court earlier. The owner of the building, David Walentas, and Jack Beyer of Beyer Blinder Belle Architects and Planners approached me in 1979 to plan a design for painting the central airshaft core of the building which would be turned into a twelve-story atrium by glassing in the roof, removing the windows in all the halls adjacent to the shaft and covering the entrance floor level of the shaft with marble and a fountain. I am now in the process of completing designs for this space that echo the rich terra cotta exterior with its Francis the First style details. The fountain, I hope, will also echo these details.

I have also made many indoor hypothetical proposals—ideas like the shadow projects that keep returning to various sites. One idea that continuously intrigues me has to do with the possibilities for decorative graveling of the large flat roof expanses that are found in our urban areas, especially near high-rise city centers and around airports

Opposite page: *Proposal: To Paint a One-to-One Replica of the Facade of Frank Furness's First Provident Bank on a Wall Adjacent to Its Original Site*, 1975, gouache on paper, 24 x 15".

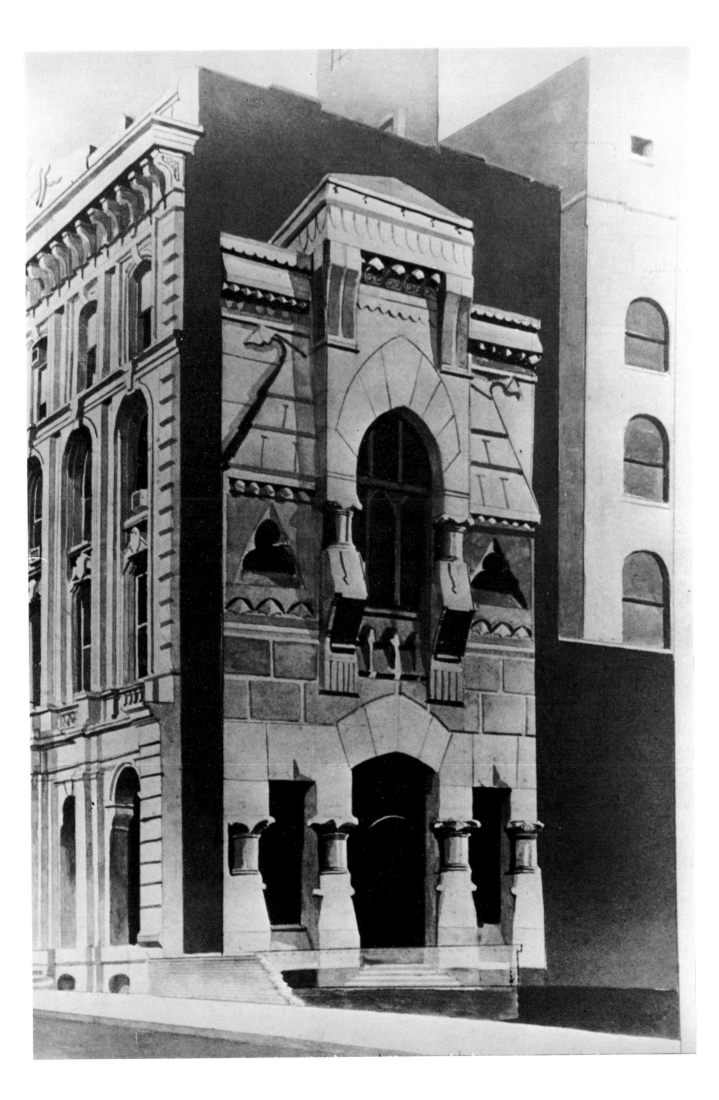

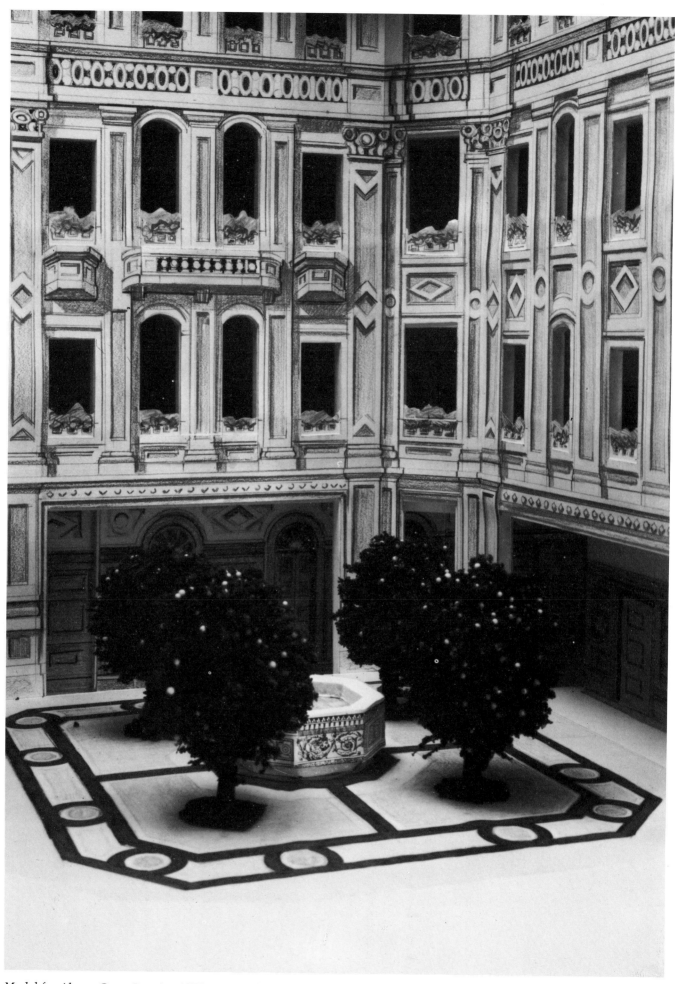

Model for Alwyn Court Interior, 1979-81, mixed media, 18 x 12 x 12".

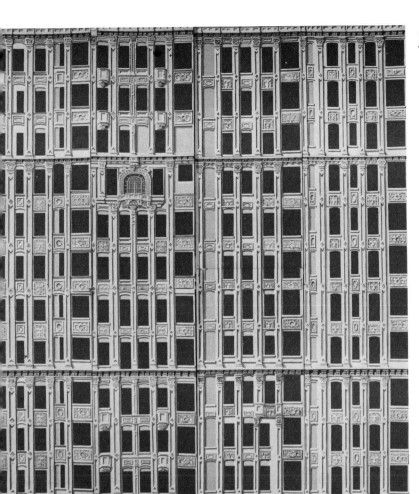

Maquette for Alwyn Court Interior, 1981,
gouache on board, 68 x 54".

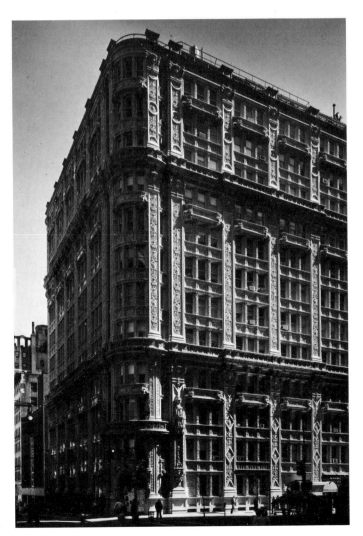

Harde and Short, Alwyn Court,
180 West Fifty-eighth Street, New York, 1909.

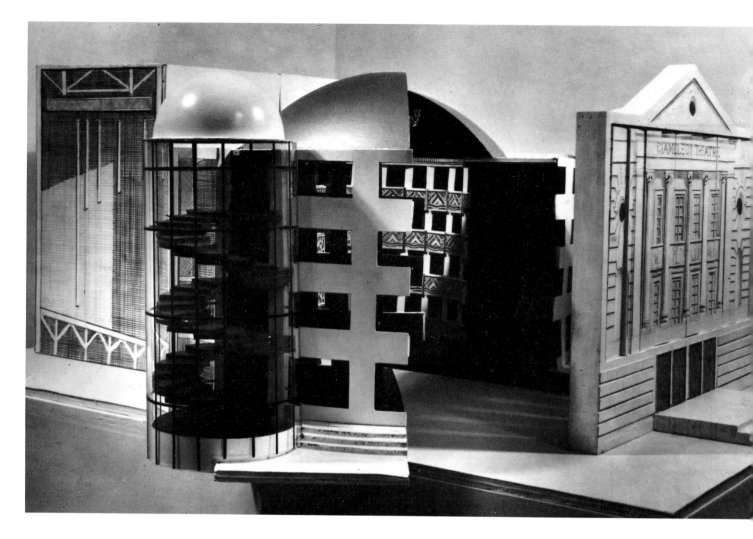

such as O'Hare in Chicago. There are endless possibilities for enriching these surfaces. For instance, the lower buildings near high-rises could be graveled in the colors and patterns of famous gardens like Vilandy, Vaux-le-Vicomte and Versailles. The large rectangular expanses of industrial parks like those west of O'Hare could be covered with carefully tarred black ground plans of great historic sites in a one-to-one scale. Imagine the Acropolis, the plan of ancient Rome or Piranesi's conception of ancient Rome spread over these sites. It is amazing how simple it would be to realize such patterns. It is also easy to imagine the endless parking lots surrounding central business districts similarly painted or tarred; the Piazza San Marco with the appropriate shadow effects of the campanile and cathedral on a parking lot in Fort Worth, for instance. Again, an easily achieved scheme.

In 1980 I visited Seattle, where a forty-story building was being built just north of the early Rainier National Bank Building. The eastern wall of the small terra cotta fronted building would now face the plaza of the bank's 1111 Third Street tower and would offer a rather ugly facade. This is a common problem in construction where a new building with a plaza takes a bite out of a block and offers few visual amenities to fill the surrounding space. The

architects unfortunately added three small one-story shops to the front of this building and thus partially masked the view of the facade that I was to paint, giving me far less than I wanted. This, coupled with the existing windows on the facade, left me with only one clean section to embellish. I designed a large reflective window for this section with an idealized view of the city and Mt. Rainier in the distance. During my design work Mt. St. Helens erupted and I decided to include a permanent memory of this moment, so I cut a flap in the window and added a view of the volcano at the peak of its eruption. Neither the bank nor any of the parties involved in the wall project wanted to see this inauspicious occurrence memorialized, so that aspect of the work was vetoed. The wall was completed with a small ceremony in February 1981.

A similar project with many difficulties surrounding it was proposed by David Bermant of National Shopping Centers for their Hamden Mall, outside New Haven, Connecticut. In the front of this mall SITE had completed a project where about ten cars were buried under tar. The wall I was asked to consider had been painted earlier with large sixteen-foot bare feet tiptoeing through tulips. It was a peeling and appalling mural. Bermant proudly announced that this was one of the first strip

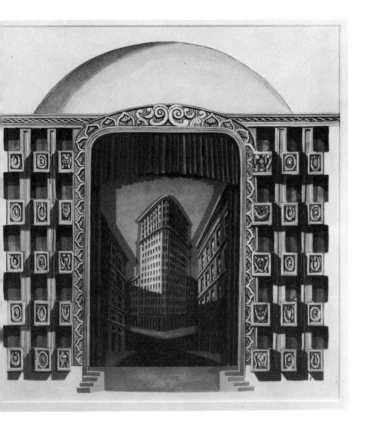

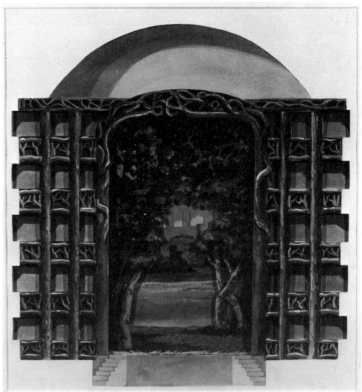

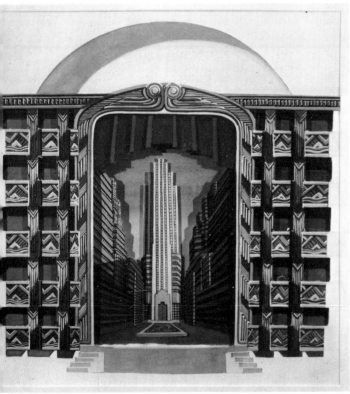

The Chameleon Theatre, 1981. Drawings and model for the exhibition "Artists Make Architecture," Rosa Esman Gallery, New York. Proposal: a 500-seat theatre with a pivoting series of front facades that change from baroque to neoclassical to Art Deco; inside balconies and stage sets could also be changed in numerous styles.

Above and opposite page: *Proposal: Baroque and Antique Ground Plans to Be Applied to the Gravel of Factory and Warehouse Rooftops*, 1981, two charcoal and chalk drawings, 18 x 20″; 20 x 24″.

shopping malls in the area and it replaced nothing more than an apple orchard. A light bulb went on in my head. Why not the buried remains of a shopping mall, seen beneath the returning flora of a future apple orchard? I also wanted to connect the work to SITE's buried car piece. The idea, however, was similar to, if not borrowed from, David Macaulay's many drawings such as those in *Motel of the Mysteries.* It seemed better to collaborate than to steal an idea, so I decided to call David, whom I've known for about four years, and ask him to work with me on the project. He was willing and we are now involved in making the final drawings for the piece.

Aerial view of factories and warehouses near O'Hare Airport, Chicago.